IMAGING A SHATTERING EARTH

Contemporary Photography and the Environmental Debate

Curated by Claude Baillargeon

With essays by Robert F. Kennedy Jr. and Maia-Mari Sutnik

Catalogue entries by Katy McCormick

Co-published by

Meadow Brook Art Gallery, College of Arts and Sciences, Oakland University, Rochester, Michigan

CONTACT Toronto Photography Festival, Toronto, Ontario

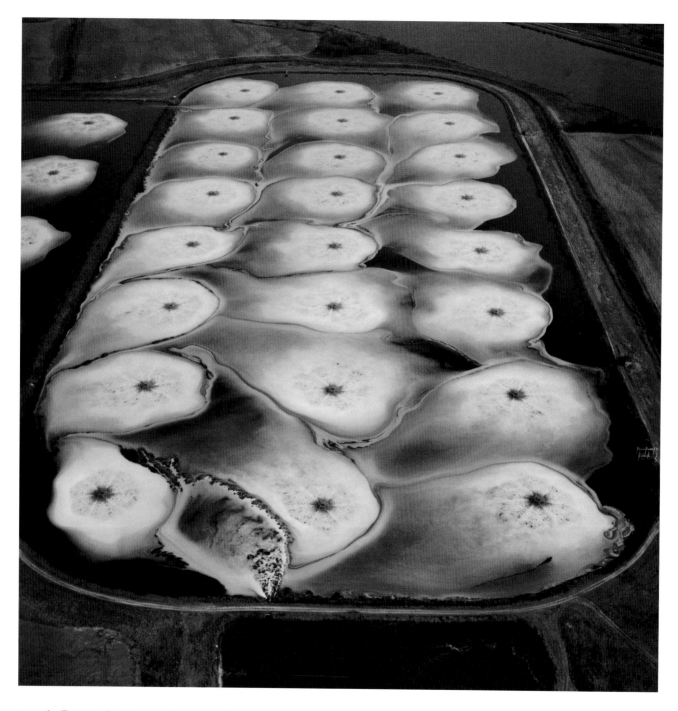

PLATE 1 Emmet Gowin, *Aeration Pond, Toxic Water Treatment Facility, Pine Bluff, Arkansas,* 1989

IMAGING A SHATTERING EARTH

Contemporary Photography and the Environmental Debate

contents

*To the memory of Tomoko Uemura (1956–1977)
and the 10,000 people affected by the Minamata disease.
Their chronic poisoning by methylmercury waste
compounds remains a cause of deep sorrow for us all.*

PLATE **2** John Ganis, *EPA Cleanup Site, Noranda Mine, Colorado*, 1998

Oakland UNIVERSITY

Oakland University, the Meadow Brook Art Gallery, and the Department of Art and Art History are delighted to host this engaging exhibition conceived as a focal point and a showcase for *Environmental Explorations*, the 2005–06 College of Arts and Sciences' liberal arts theme.

Accompanying the exhibition is a diversified program of related events, including public lectures, discussion panels, a student symposium, and the exhibition Web site created within an Honors College seminar. Please visit www2.oakland.edu/shatteringearth for details.

For their valued contributions to the exhibition catalogue, we express our heartfelt gratitude to *Environmental Explorations* guest speaker and environmental activist Robert F. Kennedy Jr., Maia-Mari Sutnik, Curator of Photography at the Art Gallery of Ontario, and Katy McCormick, Exhibition Coordinator with Gallery 44 Centre for Contemporary Photography, Toronto.

This exhibition is also part of the tenth annual CONTACT Toronto Photography Festival held in May 2006. We are doubly pleased that its scope is substantially increased through our collaboration with CONTACT 2006. We are very grateful for the support that CONTACT has provided, particularly in regard to the production of this catalogue. We are delighted that the Museum of Contemporary Canadian Art has partnered with CONTACT 2006 as the Toronto venue for *Imaging a Shattering Earth: Contemporary Photography and the Environmental Debate*.

Lastly, for instigating this exhibition project and collaboration, we thank curator Claude Baillargeon, Assistant Professor of Art and Art History. His insights into contemporary photographic practice provide an illuminating study on the effects of poor environmental stewardship.

Ronald A. Sudol
Interim Dean
College of Arts and Sciences

CONTACT

Photography's ability to communicate across national boundaries is central to an understanding of the events that define our place in a worldwide culture, as globalization stimulates an increasing cycle of interconnections through economic, environmental, political, technological, and cultural exchange. On the tenth anniversary of the CONTACT Toronto Photography Festival, we present *Imaging a Global Culture*, a series of exhibitions and events that reflect these interconnections and their dramatic increase over the past decade. Although globalization has had positive effects—including a significant increase in artistic exchange made possible, for example, by the internet—the escalating degradation of the environment and the urgent need for ecological conservation are central among our concerns.

Imaging a Shattering Earth: Contemporary Photography and the Environmental Debate tells a dramatic story about the state of global geography. This exhibition is central to CONTACT 2006 and is a welcome addition to our annual program of exhibitions, installations, films, and educational events presented throughout Toronto every May. We hope that *Imaging a Shattering Earth* will encourage dialogue about globalization and the environment and stimulate greater change.

On behalf of CONTACT's directors I would like to thank Oakland University and the Meadow Brook Art Gallery for their partnership in the presentation of this exhibition and catalogue—together we illustrate the benefits of global connections. We are especially grateful to curator Claude Baillargeon for his insightful selection of photographs and commitment to this project. We are very proud to present this exhibition in Toronto at the Museum of Contemporary Canadian Art and extend special thanks to director David Liss for his support.

Our gratitude goes out to everyone involved in CONTACT 2006, including government funding agencies, our corporate sponsors and other supporters, CONTACT staff and volunteers, and, especially, all the photographers whose vision makes change possible by helping us better understand our world.

Bonnie Rubenstein
Festival Director
CONTACT Toronto Photography Festival

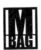

mocca

Meadow Brook Art Gallery | Oakland University | October 29 – December 18, 2005

Museum of Contemporary Canadian Art | Toronto | May 2006

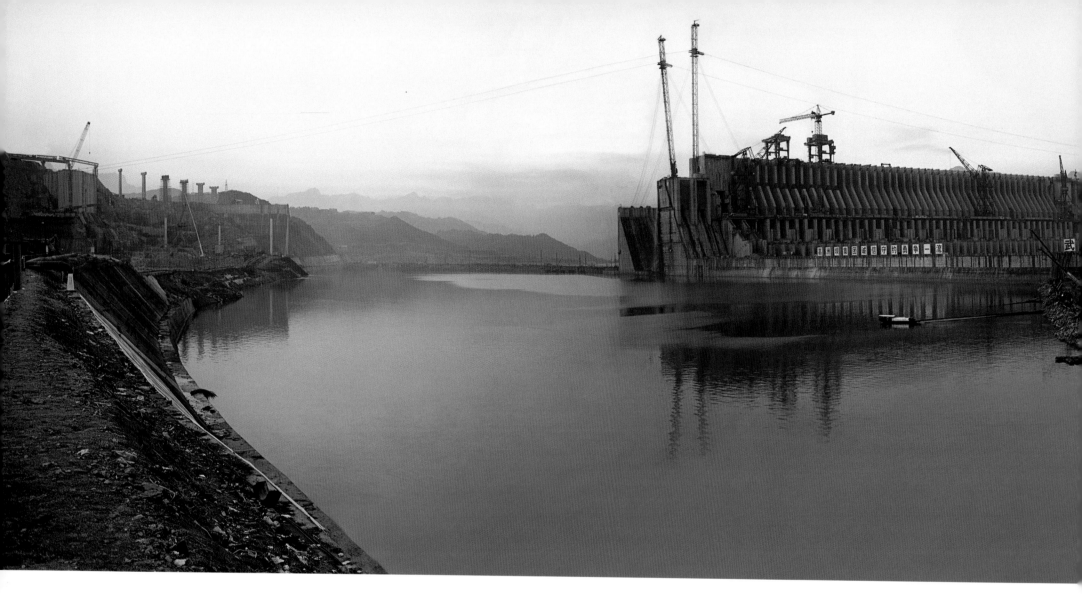

PLATE **3** Edward Burtynsky, *Three Gorges Dam Project, Dam #2, Yangtze River, China,* 2002

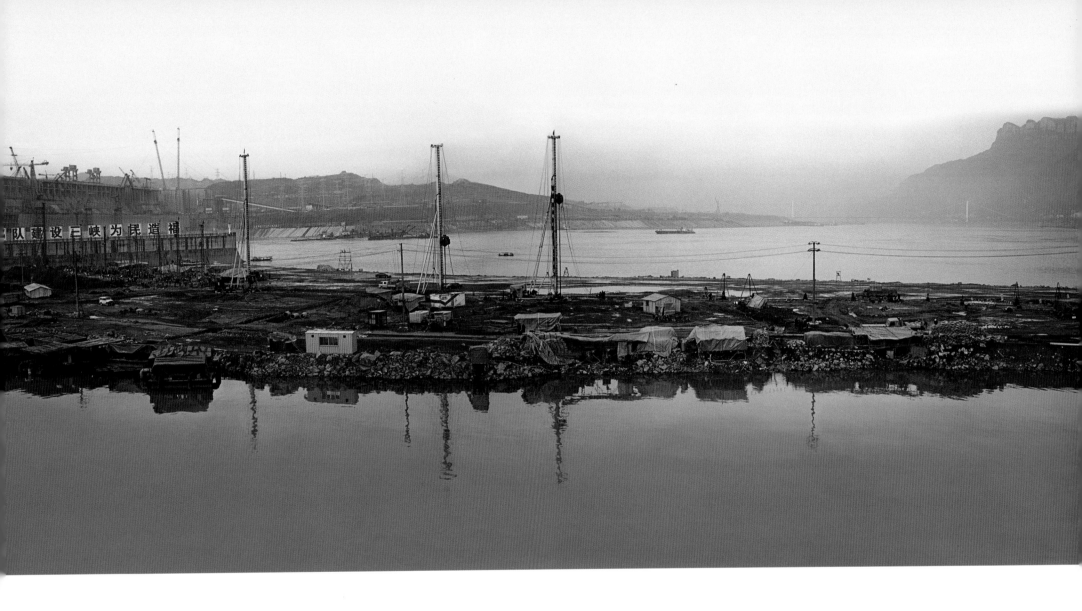

OUR WORLD IS CHANGING

Robert F. Kennedy Jr.

We are destroying it; destroying the air we breathe, the water we drink, the land that sustains us. We are laying waste to the only home we have. Over the past several decades, we have cut down more than half the world's tropical forests.

We are razing majestic mountain ranges to feed an insatiable appetite for energy. Environmental toxins that cause cancer and reproductive defects contaminate even the most remote regions of Earth. They poison the fish that we eat. They imperil our children and diminish our lives. Animals and plants that have lived for millions of years are dying off—stolen from future generations by corporate profiteers.

In 1970, the largest storm surge in recent times killed 300,000 people in Bangladesh. In coming decades, warmer ocean temperatures will cause more devastating cyclones and storm surges. Today, one-sixth of the world's six billion people live in areas prone to catastrophic flooding. Scientists predict that global warming, deforestation, rising sea levels caused by melting polar ice, and population growth will double that number by 2050. By that same year, according to the U.S. Census Bureau, the global population will have reached more than nine billion. The United Nations estimates that as many as seven billion of them may not have enough water to drink.

If the developed world's excessive lifestyle becomes the standard for the rest of the world, scientists predict that humans will require the resources of four Earths to meet our needs. More than 70% of the world's fisheries have already been depleted and pollution taints many of those that remain. Toxic metals and man-made chemicals accumulate in the food chain as bigger fish eat smaller fish. The larger the animal, the more poison it consumes, leaving those at the top of the food chain permeated with toxins. In the Norwegian Arctic, high levels of the man-made industrial chemicals polychlorinated biphenyls, or PCBs, have been found in polar bears' blood. Polar bears are turning up with both male and female sex organs and the species' birth rate is falling. Air and sea currents from Europe and East Asia transport PCBs, and although many countries banned their use in heavy industry in the 1980s, they are likely to persist in the environment for decades to come. So too will the 76 other man-made industrial chemicals, pesticides, and flame-retardants that have been found in humans, including hormone-disrupting chemicals detected in the blood of all 39 members of the European Parliament tested in a recent study by the World Wildlife Fund. Many of these chemicals are believed to interfere with the reproductive and immune systems and may be to blame for the deterioration in male fertility in Belgium, Denmark, France, and the UK over the past 50 years.

Our leaders should respect us, value us, and protect our best interests. They should force polluters to internalize the true cost of bringing products to market, for only then will they clean up their acts. When electric power companies put mercury into our air and water, they impose costs on the rest of us that should, in a true free-market economy, be reflected in the price of energy. Otherwise, we are subsidizing the polluters; allowing them to pass their costs on to us in the form of disease, developmental disability and the debasement of life.

Our environment should not be a commodity auctioned off to the highest corporate bidder. But in the United States, coal corporations are turning the Appalachian Mountains into a wasteland. Across the historic landscape, once home to Daniel Boone and other heroes who embodied American values and defined its culture, an entire mountain range is being cut down. Giant earth-moving machines called "draglines" that stand 22 stories tall and have shovels that take bites from the earth the size of a four-car garage are gnawing the tops off mountains and dumping them into river valleys and streams. Draglines have helped to bury some 1,900 kilometers of streams in the Ohio River Valley. The Appalachian Mountains are being sacrificed for my government's insane energy policy.

What is more personally painful is that my own children cannot fish in the streams and lakes of Connecticut and New York near our home, because most of their catch would be contaminated with mercury. Half of the lakes in the Adirondack Mountains just north of here are now sterilized from acid rain. All three of my children have asthma. I watch them gasp for breath on bad-air days. We are living in a science-fiction nightmare; bringing children into a world where the air is poisonous. Where I live, the poison travels from hundreds of miles away, where coal-burning power plants spew mercury, soot, and sulphur dioxide into the air. Who benefits and who suffers? That question is too easy.

I do not believe that we should preserve nature for nature's sake. We must preserve nature because it is the infrastructure of our communities. When we destroy nature, we destroy the basis of our economy. The economy is a wholly-owned subsidiary of the environment. But air, water, land and wildlife also enrich us aesthetically, recreationally,

culturally, historically and spiritually. Humans have other appetites besides money. When we destroy nature, we diminish ourselves and impoverish our children. We do not fight to save ancient forests for the sake of spotted owls. We preserve the forest because we believe that the trees have more value to humanity standing than pulped. I do not fight for New York's Hudson River for the sake of the shad and the sturgeon and the striped bass. I fight because I believe that my life will be richer, my children and my community will be richer, in a world in which shad and striped bass exist. Generations of children have grown up surrounded by the simple, carefree pleasures of the natural world. Corporate polluters have severed the legacy. I do not want my children to grow up in a world where there are no traditional fishermen on the Hudson River, where behemoth factory trawlers owned by multinational corporations strip bare the ocean hundreds of kilometers offshore. I don't want them to grow up in a world where there are no family farmers left, where the only place to get food is from a factory. I do not want them to grow up in a world where we've lost touch with the seasons and the tides and the things that connect us to the ten thousand generations of human beings who came before.

Each mountain flattened, each river contaminated, each breath of fresh air polluted, is a vital piece of our world lost. Yet even as I watch the planet being destroyed river valley by river valley, ecosystem by ecosystem, I have hope. I believe we can save it in the same way: one river at a time, one town at a time. We start with ourselves, tending first to our own communities and, eventually, to the valleys and mountains beyond.

Indigenous people can guide us. They have resisted the corporate culture that sustains itself by liquidating natural resources. Their relationship with the Earth is like that of the traditional family farmer before corporate, chemical farming broke the pact with nature. All they want is a sustainable yield that maintains the land's richness for their children. I look to the Native Americans in northern Quebec for inspiration. They turned down $2 billion offered for their endemic land along the tributaries of James Bay, a region that the energy industry wanted to flood for hydropower production.

The Cree and Inuit live in teepees through sub-zero winters. They hunt caribou, geese and rabbits. They are one of the most poverty-stricken people in Canada, yet they reject the corporate come-ons that are now the principal threat to both democracy and the global environment. These populations understand that wealth is not just about money; that in a true free market economy you cannot make yourself rich without enriching your community at the same time. No amount of money can replace their ancestral wealth–pure air, water, and land.

I see hope for our future in the small Mexican fishing village of Punta Abreojos in Baja California. The community as a whole manages its abalone, lobster, and oyster fisheries. Everybody in the village has a stake. The community guards against over-fishing by poachers. Because of their environmentally sensitive practices, their catches command premium market prices. They share the costs of sustainable production and they share the fruits of their labor. There the people are not wealthy by American and European standards, but they have pride in their homes and their livelihoods. There is a real richness to life. These are people who are living sustainably and are protecting their resources for future generations.

Environmentalists believe that we cannot sell the farm piece by piece to pay for the groceries; we cannot treat the planet as if it were a business in liquidation, squandering the birthright of all future generations. We must stop invading our principal and learn to live off its abundant interest. That would be a reward unto itself, as would the knowledge that we were leaving to our children a healthier planet than was left to us.

This essay was originally published in *Vogue Hommes International* (fall/winter 2004–05) and is reprinted here courtesy of the author and Condé Nast Publications.

PLATE **4** Robert and Shana ParkeHarrison, *The Marks We Make,* 2003

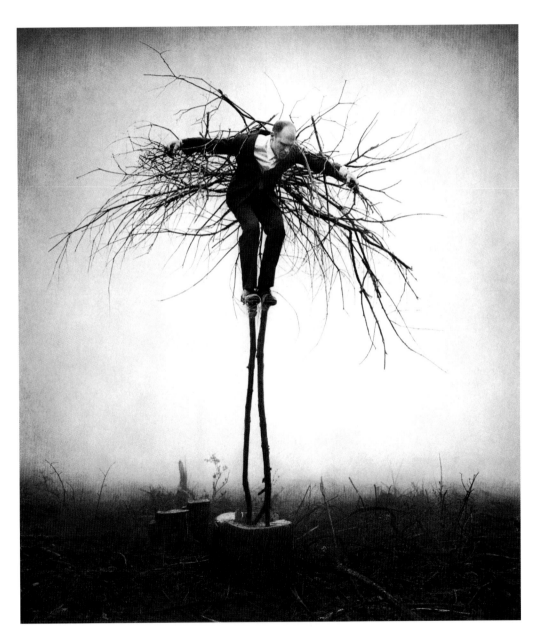

PLATE 5 Robert and Shana ParkeHarrison, *The Guardian*, 2003

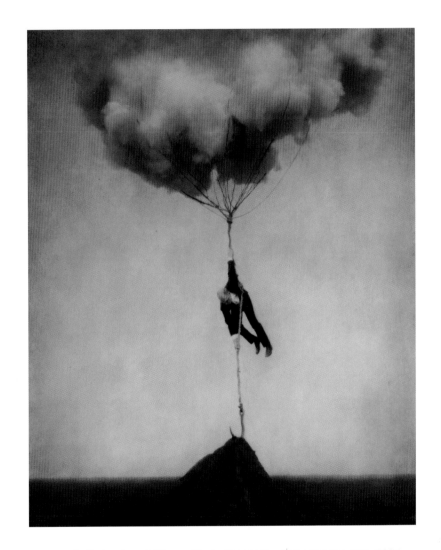

PLATE 6 Robert and Shana ParkeHarrison, *Tethering the Sky*, 2004

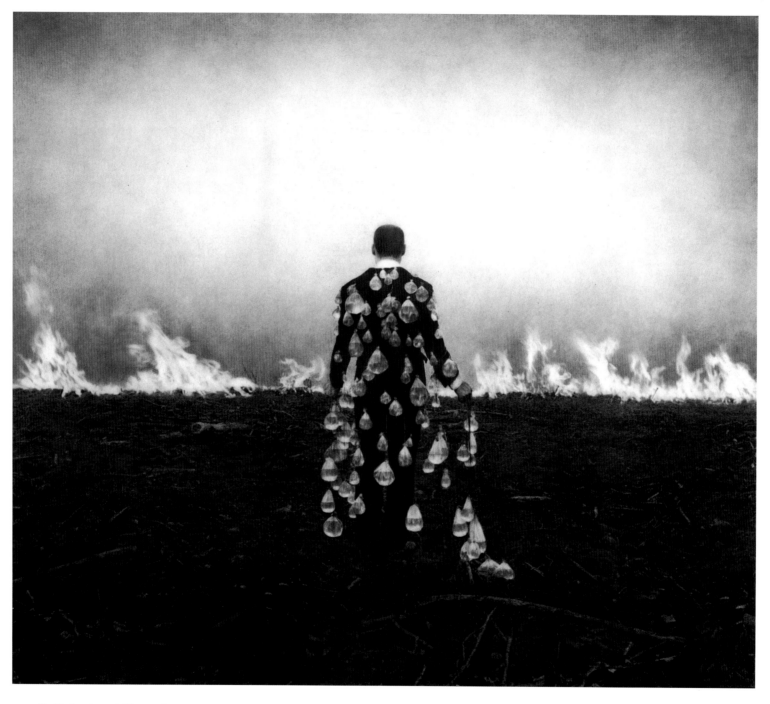

PLATE **7** **Robert and Shana ParkeHarrison,** *Burn Season,* 2003

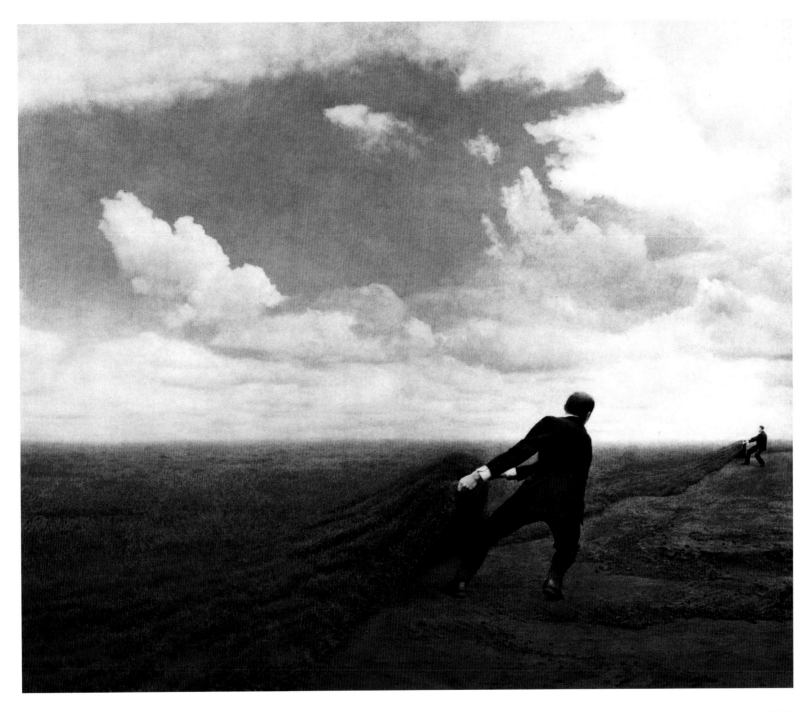

PLATE **8** Robert and Shana ParkeHarrison, *Reclamation*, 2003

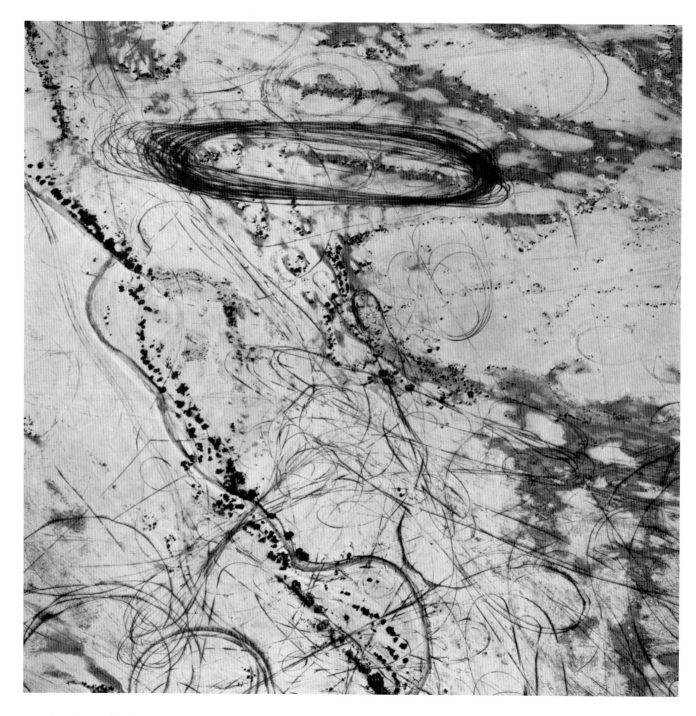

PLATE **9** Emmet Gowin, *Off Road Traffic Pattern along the Northwest Shore of the Great Salt Lake, Utah,* 1988

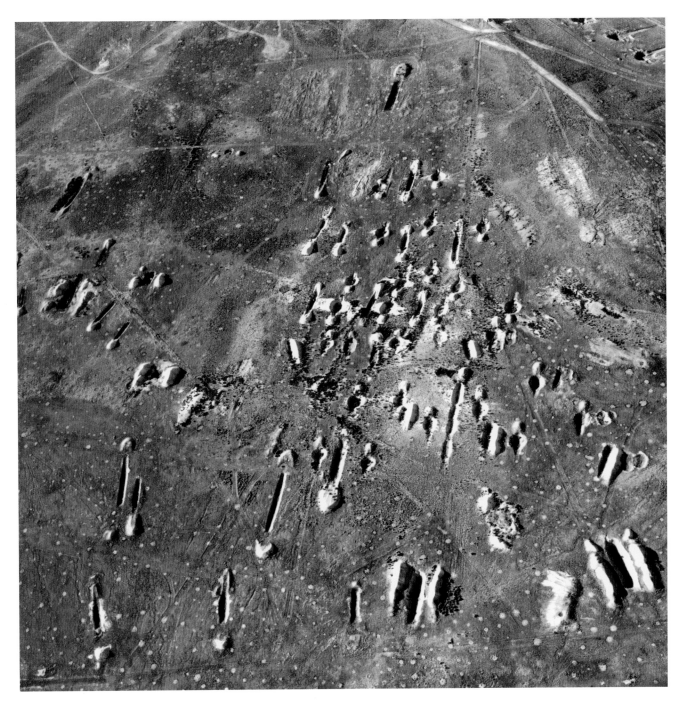

PLATE 10 Emmet Gowin, *Weapon Disposal Trenches, Tooele Army Depot, Utah*, 1991

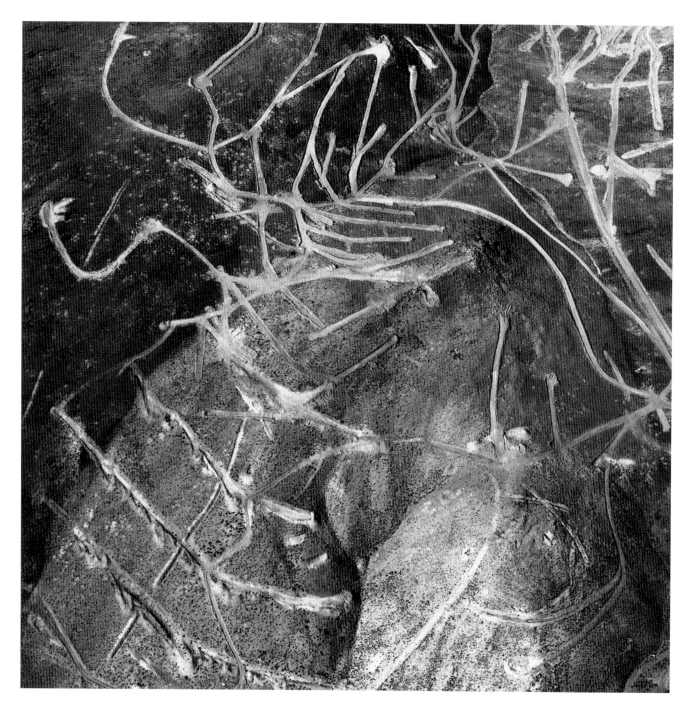

PLATE **11** Emmet Gowin, *Mining Exploration near Carson City, Nevada,* 1988

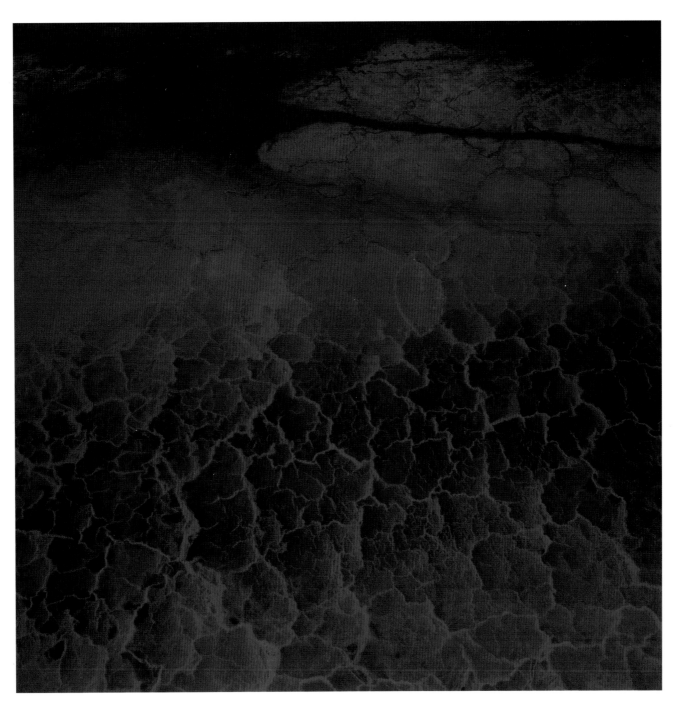

PLATE **12** David Maisel, *The Lake Project #9273-8,* 2001–02

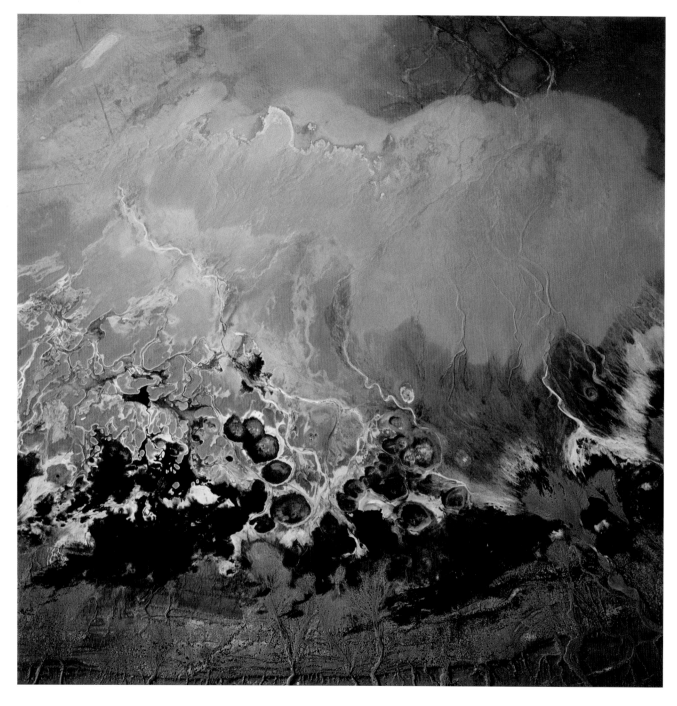

PLATE **13** David Maisel, *The Lake Project #9802-9,* 2001–02

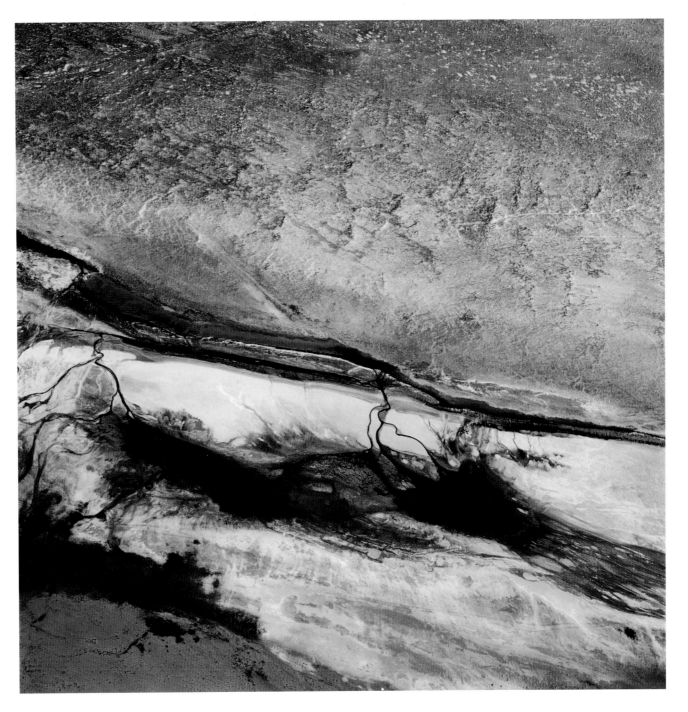

PLATE 14 David Maisel, *The Lake Project #9825-5*, 2001–02

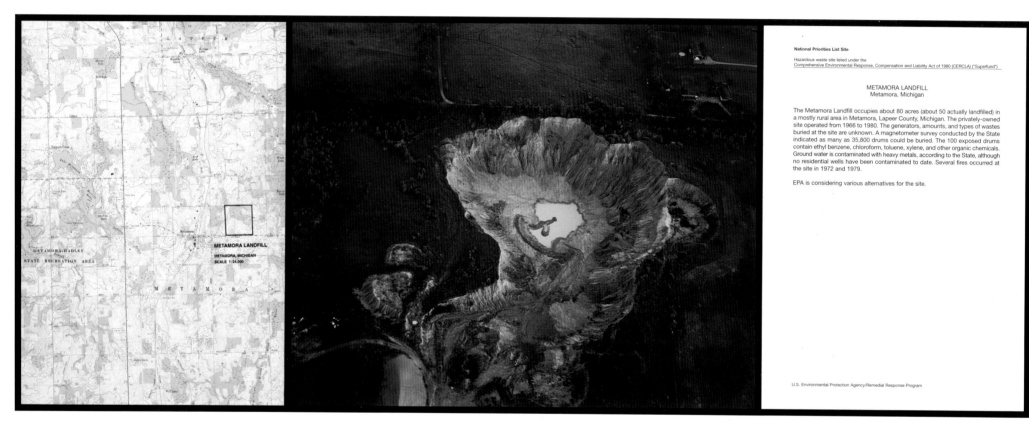

PLATE 15 David T. Hanson, *Metamora Landfill, Metamora, Michigan,* 1986

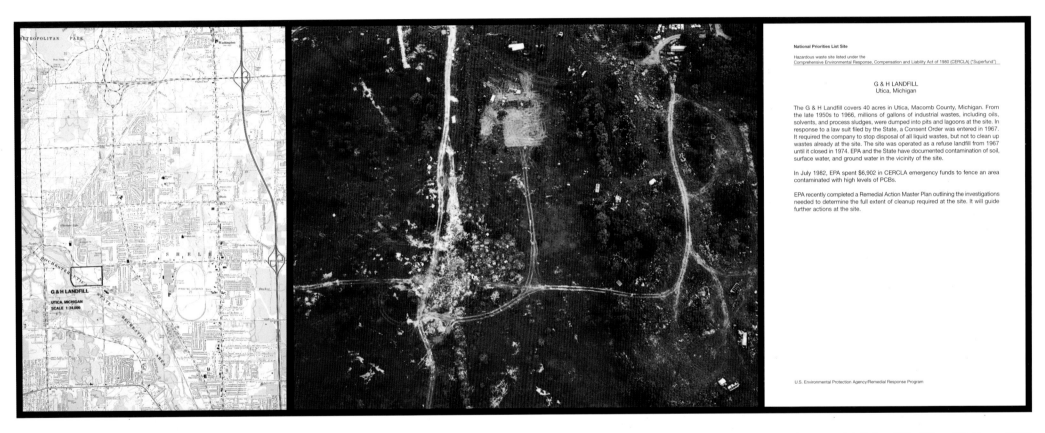

G & H LANDFILL
Utica, Michigan

The G & H Landfill covers 40 acres in Utica, Macomb County, Michigan. From the late 1950s to 1966, millions of gallons of industrial wastes, including oils, solvents, and process sludges, were dumped into pits and lagoons at the site. In response to a law suit filed by the State, a Consent Order was entered in 1967. It required the company to stop disposal of all liquid wastes, but not to clean up wastes already at the site. The site was operated as a refuse landfill from 1967 until it closed in 1974. EPA and the State have documented contamination of soil, surface water, and ground water in the vicinity of the site.

In July 1982, EPA spent $6,902 in CERCLA emergency funds to fence an area contaminated with high levels of PCBs.

EPA recently completed a Remedial Action Master Plan outlining the investigations needed to determine the full extent of cleanup required at the site. It will guide further actions at the site.

U.S. Environmental Protection Agency/Remedial Response Program

PLATE **16** David T. Hanson, *G & H Landfill, Utica, Michigan*, 1986

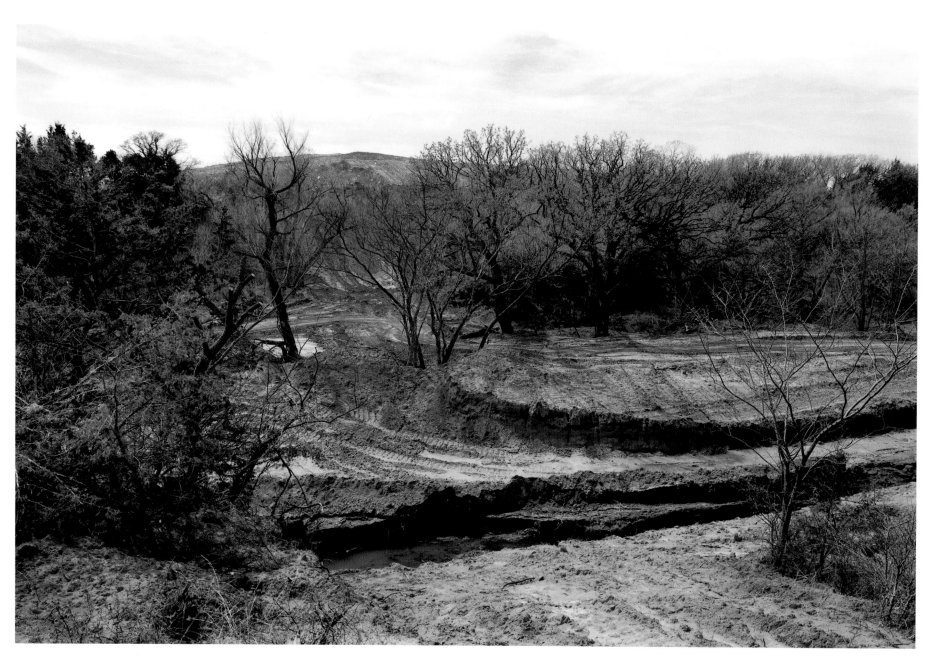

PLATE **17** John Ganis, *Edge of a Landfill, Oklahoma*, 1989

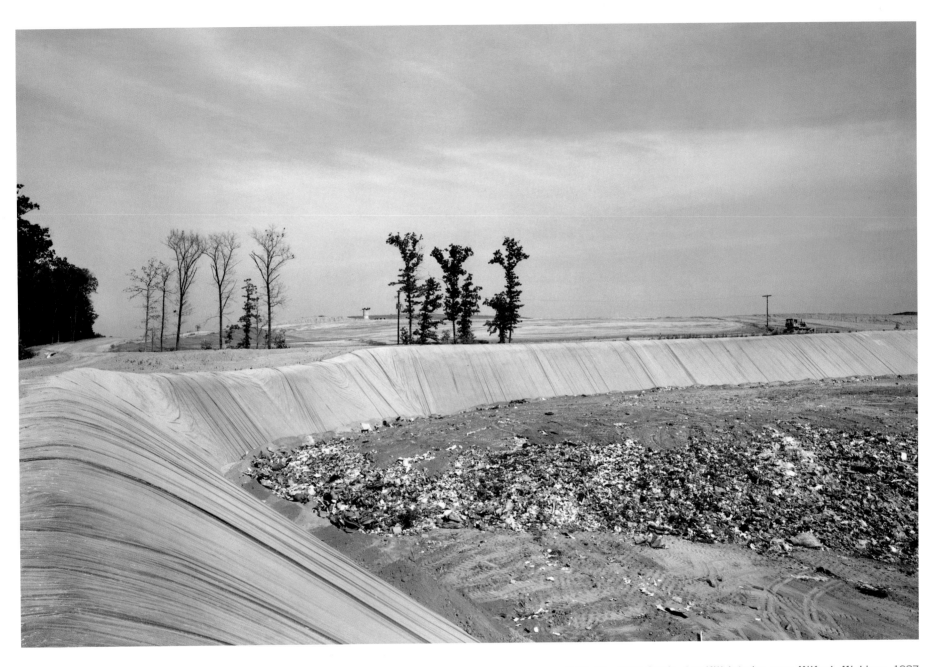

PLATE **18** John Ganis, *Landfill Interior, near Milford, Michigan*, 1987

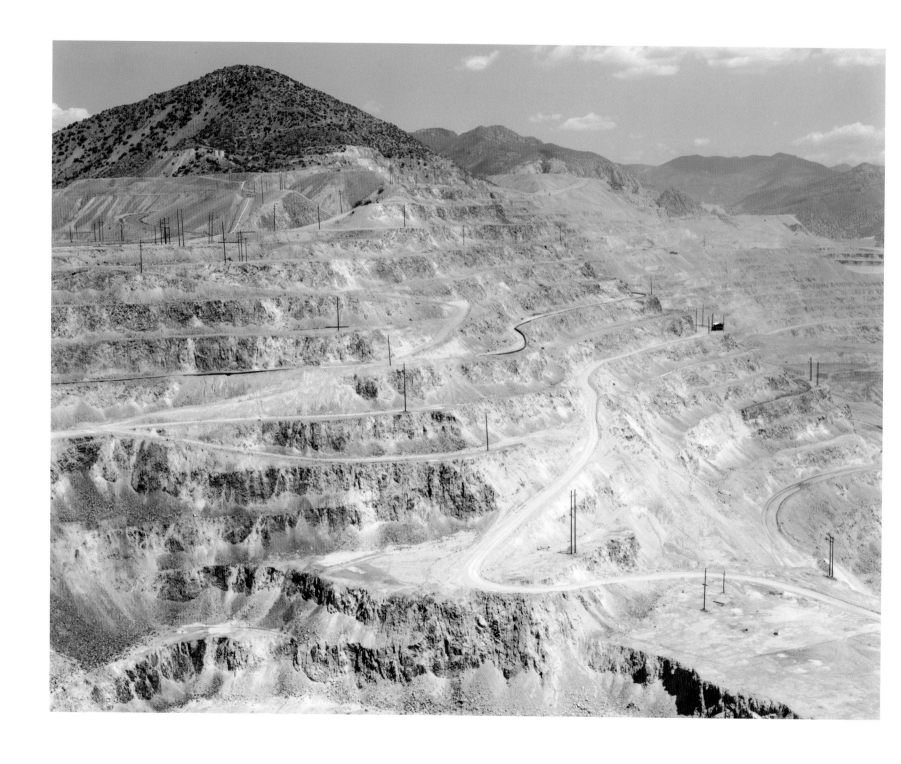

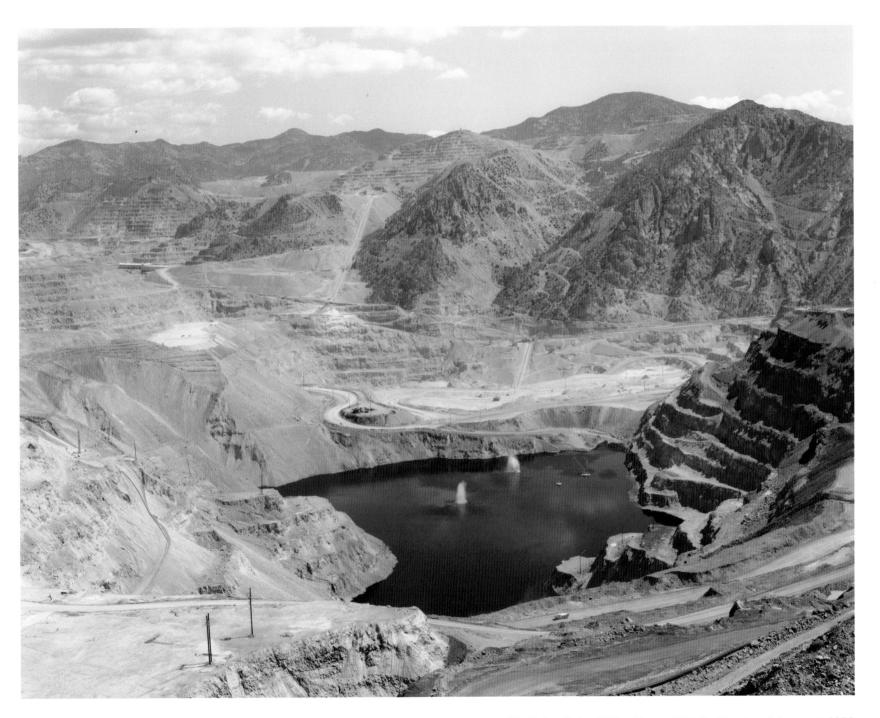

PLATE 19 Peter Goin, *Clifton-Morenci Pit, Southeastern Arizona*, ca. 1992

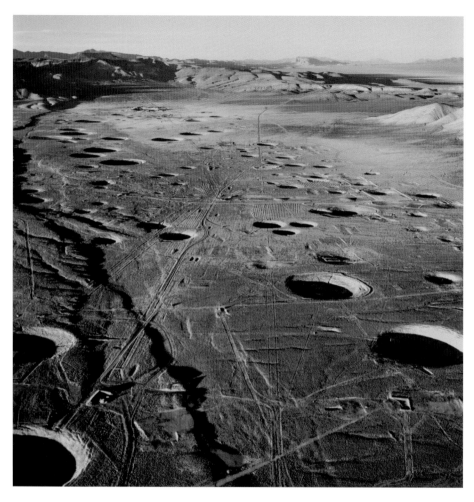

PLATE **20** Emmet Gowin, *Subsidence Craters, Northern End of Yucca Flat, Nevada Test Site*, 1996

But so full is the world of calamity,

that every source of pleasure is polluted,

and every retirement of tranquility disturbed.

— Samuel Johnson, 1752

Claude Baillargeon
IMAGING A SHATTERING EARTH

Conceived as a rallying cry against the ecological degradation of our world, *Imaging a Shattering Earth* explores the detrimental impact of humankind on the land, a phenomenon decidedly on the rise since the industrial revolution. While natural calamities like earthquakes, tsunamis, hurricanes, floods, and fires wreak havoc upon the environment, this exhibition and its catalogue underscore human-induced threats and damages. Without attempting to present a comprehensive survey, this project brings together fifty-six works by twelve North-American artists, whose photographs bear witness to an increasing sense of urgency. Effective as catalysts for reflection and debate, these images are forceful reminders of the growing dangers we all face. Collectively, they argue for the necessity of concerted actions against the progressive "shattering" of the earth.

By assuming a certain distance from their subject, these artists enable us to view a pattern of reckless stewardship of our planet. Whether achieved by means of bird's-eye views, panoramic sweeps, wide-angle lenses, large-format negatives, extended depth of field, or other compositional devices intended to suggest a sense of remote space, these photographs aspire to convey the big picture. Though each of the subjects represented can be pinpointed on a map, as evidenced by the work of David T. Hanson, the depicted terrain remains a kind of "every land"—a shared earth, rather than "my yard" or "my father's farm." Thus, it is our communal estate, our planet as a whole that is shown in jeopardy. Removed from the realm of domesticity, these works look beyond our individual rapport with the environment, our household water usage, recycling efforts, and fuel consumption in order to foreground the impact of societal behaviors, industrial practices, corporate priorities, and governmental policies.

Predicated on a direct observation of the earth's altered topography, the selected works (with the notable exception of those by Robert and Shana ParkeHarrison) share a propensity for objectified representation. Whether decontextualized to the point of abstraction, as in the intriguing earth markings of Emmet Gowin and David Maisel, or presented matter-of-factly, as in the graphic testimonies of John Ganis and Peter Goin, part of the intent behind these pictures remains to expose the physical scarring of the earth. Ranging in scale from diminutive to colossal, each print exemplifies its maker's reliance upon a synthetic, outward-looking vision. Yet, for all the remoteness of their imaging strategies, these works aim to engage viewers in a collective process of soul-searching.

Although seemingly paradoxical, this unrelenting call to attention coexists with a steadfast preoccupation with the formal aspects of the image-making process. Indebted to the heroic

tradition of exploratory landscape photography initiated in the nineteenth century by the likes of Carleton Watkins, Timothy O'Sullivan, and William Henry Jackson, the photographers pay close attention to the medium's syntax and history. While preoccupied with the depiction of environmental traumas in need of remedial actions, these advocates also aim to produce enduring works of art that maintain a level of open-endedness. Combining references to the picturesque, the beautiful, the sublime, and the spiritual provides an effective means to attract viewers' attention in order to trigger philosophical musing and critical inquiry.

Yet, unlike their nineteenth-century precursors, whose often commercially commissioned images reflect the then prevalent doctrine of manifest destiny, these contemporary practitioners view the underlying notion of progress and its recasting in the guise of globalization with suspicion. Taking their cue from an alternative landscape tradition that evolved in the 1970s around the landmark exhibition *The New Topographics: Photographs of a Man-Altered Landscape* (George Eastman House, 1975), they reaffirm the primacy of the acculturated landscape as a timely subject of investigation. This affinity can be seen in their shared rejection of the earlier paradigm of nature as a teleological manifestation. While those who subscribed to the New Topographics idiom showed a predilection for unglorified tracts of land and nondescript suburban developments, these landscape photographers favor industrial complexes, mining sites, dried-up lakes, landfills, waste ponds, and other exclusion zones. In both cases, the issue is one of human incursion upon land that was once regarded as pristine, relatively isolated, scarcely inhabited, and yet rich in natural resources and commercial opportunities. Though people rarely appear in these compositions, their impact is all pervasive. Unlike the New Topographics practitioners, however, maintaining the appearance of neutrality and authorial self-effacement is not a shared concern with the present group of artists.

Prior to the 1970s, few photographers expressed misgivings about the exploitation of natural resources and the potential repercussions of their processing. The depiction of industrial facilities first gained prominence at the turn of the twentieth century with the Pictorialists, who romanticized these smoke-filled complexes by imbuing them with metaphoric symbolism as part of their photography-as-art crusade. Meanwhile, others like Lewis Hine chastised the ruthless exploitation of child labor by greedy industrialists oblivious to health hazards. In sharp contrast, with the advent of the machine age that reached its apogee in the 1920s, a number of leading exponents of Modernism, none more prominent than Charles Sheeler, viewed industry with a reverence that verged on religiosity. This sentiment began to fade with the hardship and disillusionment springing from the Great Depression. Among the earliest evidence of the changing attitude is Walker Evans's 1935 sardonic portrayal of Bethlehem, PA, in which a working-class cemetery is deliberately foregrounded against the community's steelworks.

Still, one must wait until the early 1970s to experience a full-fledged expression of the power of photography to affect social consciousness vis-à-vis the evils of industrial production. Infuriated by the startling evidence of chronic poisoning in the Japanese community of Minamata, the renowned photojournalist W. Eugene Smith and his wife Aileen spent three years documenting the tragic predicament of the victims and their families. Caused by the uninhibited release of methylmercury waste compounds in the waters of a nearby fishing village and the ensuing contamination of the food chain, the Minamata disease is a neurological disorder that has affected more than 10,000 people, many of whom were poisoned while still in their mothers' womb. Determined to expose the horrors of the disease, the suffering of its victims, and the negligence of the Chisso executives, Smith and his wife produced powerful images, the most memorable of which shows Tomoko Uemura, a blind sixteen-year old, being tenderly bathed by her mother.

Just as there are different sorts of environmental debate, there are various types of environmental photography, as neither represents a singular universal entity. Although this exhibition does not explore photojournalistic environmental photography, this genre remains a persuasive means to raise public consciousness. This can be seen, for example, in Sharon Stewart's *Toxic Tour of Texas* (1992), a body of work that combines representations of waste disposal sites and portraits of concerned citizens with written testimonies to underscore the need for and the value of grass-root activism. Also exploring the combined effect of poisoned landscapes, affected workers, and their oral histories is Carole Gallagher's *American Ground Zero: The Secret Nuclear War* (1993), a powerful indictment of Cold War ideology.

As research for this exhibition evolved, it became increasingly evident that few women work within the previously outlined parameters. As the cultural critic Lucy Lippard contends, "many women photographers, like many women public artists, are more interested in the local/personal/political aspects of landscape than in the godlike big picture, and tend to be more attuned to the reciprocity inherent in the process of looking into places. Their approach might be called vernacular."[1] A case might also be made that social conditioning predisposes men towards big trucks, heavy machinery, mining sites, industrial zones, and military endeavors. Might women be more mindful of the dangers of toxic chemicals upon the body and their effects on reproductive health? Are they perhaps more reticent to expose themselves and their photographic plates to the insidious effects of radioactive radiation and toxic waste (mis)management?

Whatever the case may be, this perplexing issue is undoubtedly foregrounded by the present selection, which is organized according to three recurring preoccupations. The first explores the scarification of the earth's surface as a result of human interventions. The second

addresses the exploitation and management of natural resources. The third focuses on the afterlife of sites deemed irretrievably damaged. These shared concerns reflect the multiple links to be found between the various bodies of work. In the exhibition, certain notorious sites are depicted by more than one photographer, emphasizing both a plurality of perspectives and the degree of danger contained therein. Ultimately, the works in this exhibition are meant to reveal a pattern of monolithic degradation.

The Marks We Make

In Robert and Shana ParkeHarrison's on-going lament for the planet, a mostly solitary male figure dressed in corporate attire performs the Sisyphean task of restoring a post-apocalyptic landscape. Recalling Antoine de Saint-Exupéry's *Little Prince* (1943) and the cosmic journey that landed the inquisitive fellow in the Sahara, this lone wanderer, driven by a sense of urgency, attempts by every conceivable means to salvage and rejuvenate what remains of the old world. In *The Marks We Make* (plate 4), he is seen spiraling from a rope tied to his ankles, while the stick in his hands scratches the crust of the earth in a rhythmic pattern ironically echoing the practice of pivot agriculture favored by large farming conglomerates in the American Midwest. Seen from the air, the resulting concentric circles exhibit a formal beauty that belies the dangers of exhaustive agrarian practices. With his watchful eye and proactive engagement towards reclamation, this earth guardian can be viewed as a metaphoric surrogate for all the photographers in the exhibition, who are committed to exposing the uncertain future of our ecological universe.

Inspired to write *The Little Prince* while flying as a professional pilot, Saint-Exupéry was well acquainted with the revelatory dimension of aerial perspectives. As we all know from air travel, the experience of viewing familiar grounds from above can be both disorienting and exhilarating. By drastically altering customary spatial relationships with our surroundings, airborne photography fosters a heightened sense of curiosity, while providing all-encompassing points of view from which to meditate upon the earth's transformation. Seen from above, the impact of urban expansion, industrial processing, hydro-engineering, mining, deforestation, waste management, military testing, and other invasive practices is seen on the monumental scale in which it unfolds. Often employed as a means of surveillance and as a mapping device, the technique of aerial photography is proving equally beneficial to environmental artists eager to reveal what is too often concealed from scrutiny at ground level. This approach is particularly effective as a means to circumvent restricted access, while maintaining a safe distance from the health hazards on the ground.

Both of these advantages were useful to David T. Hanson in his *Waste Land* series, which amalgamates topographical maps, aerial views, and government reports to draw attention to the worst toxic sites on U.S. soil. With verbatim transcriptions of the Environmental Protection Agency's "Superfund" National Priorities List as his only text, Hanson asserts both the magnitude of the problem and the implicated corporations' lack of accountability and delaying tactics. Yet, the ineffectual rhetoric of this Remedial Response Program emerges from its juxtaposition to Hanson's detailed surveillance-like photographs and to the U.S. Geological Survey maps marked to indicate the exact locations of the hazardous sites, many of which are situated in close proximity to densely populated areas. This is the case, for example, with the G & H Landfill in Utica, MI (plate 16), which borders the Rochester-Utica State Recreational Area south of Twenty-Three Mile Road, some eight miles east of Oakland University's Meadow Brook Art Gallery. Hanson's placement of appropriated maps and texts on either side of his aerial photographs also serves to remind us of the semiotic crossovers between these three forms of sign. Beyond their common reliance upon bird's eye views, both survey maps and aerial photographs share an indexical bond with the terrain they represent. Furthermore, all maps, photographs, and texts are signifiers that require interpretive reading to yield significant meaning. Hanson's *oeuvre*, an unambiguous indictment of current practices, retains this theoretical dimension.

The dichotomy between disorientation and wonderment that accompanies flying has led a number of artists, among them Emmet Gowin and David Maisel, to explore the introspective potential of aerial photography. Fascinated with the medium's ability to transform as it records, these artists view the photographic process as a means to engage spiritually and holistically with the world. Spurred by the deteriorating condition of our ecosystems, their preferred strategy is to craft alluring images fostering contemplation, in the belief that this will lead to enlightenment. This, they assert, can be achieved by foregrounding the ambiguous sublimity of the ravaged landscape, thereby exposing the paradoxical relationship between degradation and beauty.

This shared concern is particularly evident in their many abstract, horizonless compositions, which are devoid of clues to scale, spatial relationships, and orientation, despite the vastly different dimensions of their respective photographs. As in the all-over compositions of the Abstract Expressionists, these square fragments of wounded terrain exude a formal strength which brings out and gives relevance to the marks and patterns animating their visual fields. Entranced by their rhythms and modulations, our mind's eye struggles to reconcile what it perceives with what is actually represented. While discovering the identity of the subjects can be startling, the spell of these engrossing pictures remains and their evocative presence is renewed with each successive viewing.

Consider, for example, David Maisel's *Lake Project*, one of several chapters from his on-going *Black Maps* investigation of despoiled landscapes. Though ostensibly inscrutable, these highly saturated images (plates 12–14) represent the drainage remnants of California's Owens

(dry) Lake, once a 110-square mile shallow body of water depleted in a mere thirteen years (1913–26) to meet the freshwater needs of Los Angeles. In the summer, the ecosystem of the desiccated lakebed, unusually rich in minerals, induces the proliferation of microscopic bacterial organisms, which turn residual water pink or even blood red. Yet, this striking phenomenon conceals the fact that windy conditions give rise to toxic dust storms laden with micro dust particles, including traces of carcinogenic cadmium, chromium, arsenic, and other hazardous materials.[2]

The consequences of an unabated exploitation of the planet are made clear in every picture in this exhibition, save for those grappling with the invisibility of nuclear radiation. From the incriminating evidence of toxic and household waste mismanagement, deforestation, and other environmental abuses garnered from coast to coast by John Ganis to the scarification and gouging inflicted by a plethora of mining activities, the earth is shown as deeply disturbed and in need of healing. Though resilient, our ecosystems cannot indefinitely withstand the relentless depletion of non-renewable resources, nor can the unabated onslaught of hazardous wastes and heat-trapping compounds be successfully reversed with current technologies.

Resource Industries

The exploitation and management of natural resources figure prominently amidst the concerns of environmental photographers. From the extraction of raw materials to the by-products of their industrial processing, the resource industries encompass a broad array of commercial practices, many of which can be detrimental to the environment. Though some resources, like timber, are potentially renewable, only close monitoring and binding regulation by independent agencies and non-commercial interests can ensure sustainability. Rarely reported on, this issue is brought to light, for example, by the clear-cutting photographs of John Ganis, who has documented the for-profit deforestation taking place within certain U.S. national forests. How startling, for instance, to be confronted with the aftermath of a federal timber sale in Oregon's Willamette National Forest (plate 23), when the very notion of a "national forest" would imply some form of careful governmental guardianship "for the people."

Foremost among the determinant forces driving the exploitation of natural resources is our insatiable hunger for energy, be it hydro-electric, nuclear, oil based, coal, or derived from alternative sources. Emblematic of this condition is the global quest for fossil fuel, a subject that is increasingly probed by concerned photographers. Whether they focus on the controversial handling of petroleum in the Alaskan wilderness, the ravaged landscape of Alberta's oil sands, the spoil of coal strip-mining in Southern Illinois or the Czech Republic, or even the massive extraction of low-grade coal by the Chinese, the central issues remain the short-sighted custodianship of our resources and the failure to account for the true costs, in environmental terms, of energy. A case in point is John Ganis's portrayal of the Alaska pipeline (plate 21), in which an aluminum-sheathed conduit invades the otherwise majestic frontier like some bionic earthworm. If the price of energy is spoil, should it not cost more? And if it did, would we not use it more efficiently?

As a graduate student at Southern Illinois University, Carbondale, Jonathan Long used a swiveling panoramic camera to capture Dantesque sweeps of abandoned coalmine waste. In *Black Canyon* (plate 27), a site now undergoing reclamation as part of the Sahara Woods State Natural Area, Long lowered his camera into the miasma of the mining gob to accentuate its desolation and the ghastly stream of rusty water leaching out of the rocks. In *Broken Trees* (plate 26), he provides stupefying evidence that the apocalyptic wasteland envisioned by Robert and Shana ParkeHarrison already exists in the heartland of America. Though reclamation may be underway in these devastated areas of Southern Illinois, it is alarming to think that mining lobbyists are now increasingly calling for deregulation and the easing of the very policies that curtailed these lawless abuses of the past century.

In China, the craving for energy is exacerbated by the politics of globalization that seek larger markets and reduced production costs to the detriment of environmental safeguards and human rights. As the new superpower asserts its growing prominence on the world stage, its energy needs increase exponentially. With a booming economy supported by a plentiful workforce, China is answering its energy challenge with projects of unprecedented ambition and far-reaching consequences. Nowhere is this more evident than in the Three Gorges Dam under construction across the Yangtze River. Begun in 1993, it will stand upon completion in 2009 as the world's supreme leviathan of hydro-electric facilities. With a span five times that of Hoover Dam, the resulting megastructure will result in the flooding of "13 major cities, 140 towns and over 1,300 villages." The already-begun inundation is forcing the evacuation and resettlement of an estimated 1.13 million people.[3]

In Edward Burtynsky's monumental panoramic depiction of the Three Gorges Project (plate 3), the unmitigated faith in progress that propels the risky enterprise is sure to consume the age-old serenity of the riverscape. Unfazed by the potentially cataclysmic repercussions of this impetuous tampering with nature's order of things, the promoters proudly assert in bright red calligraphy "Ge Zhou Dam Group is honest and doing our best" (on the left), while proclaiming that "The Police Hydro-Electric Construction Department is building Three Gorges Dam to make people happy" (on the right).[4] While such propagandistic bravado may be designed to assuage local sentiment, the message fails to reassure the world community mindful of seismic dangers and other environmental pitfalls.

Further exemplifying China's wholesale exploitation of its natural resources are the fifty million tons of coal that the country extracts from the bowels of the earth and burns on an

annual basis.[5] In Tianjin, the banks of the port of Tanggu are filled with mountains of coal spreading as far as the eye can see (plate 28). Consumed in enormous quantities by the steel industry, which continues to rely extensively upon coal-fired generators, the carbonized mineral can be found in abundance in parts of China. According to current data, there are "over a trillion tonnes of the proven coal reserves lying under Chinese soil—or more than 500 years of production at current levels."[6]

Among the main Chinese coal users is Shanghai Bao Steel Group, which ranks as the sixth producer of steel worldwide. In 2005, it is estimated that this single plant will consume more than eighteen million tons of high sulfur, dirty burning coal, a major source of smog, acid rain, and mercury contamination, the latter of which finds its way into our bodies through the consumption of fish. In the Burtynsky photograph that graces the cover of this catalogue, Bao Steel's on-site coal reserves are viewed from a perspective reminiscent of the ceremonial plaza facing the Pyramid of the Moon at Teotihuacán. With the symmetrically disposed structures and the obelisk-like smokestacks rising beyond, Burtynsky's rigorous composition conflates, in both formal and conceptual terms, the rational spatial organization of an ideal Renaissance city with the eeriness of the Aztec metropolis. Hence, this nearly monochromatic study, with its strong contrast of light and dark, can be read both as a symbol of China's rising fortune and a foreboding sign of the environmental challenges ahead.

A prime example of catastrophic outcome related to large-scale strip mining can be found in northern Bohemia, Czech Republic, where during the Cold War the now fallen Soviet regime sacrificed close to a million acres of land in the pursuit of cheap coal. To reach the coal-seam buried two hundred feet below the surface, more than a hundred traditional land-based communities were relocated in housing projects with few prospects of livelihood outside of mining. To make matters worse, the local people now live surrounded by discarded overburden and effluent holding ponds, and their health is affected by the acid rain which falls as a result of the pollution still spewing out of the seven power stations built by the State. In one of his photographs from the devastated region (plate 41), Emmet Gowin conveys the palpable horror of the poisoned landscape where the 800-year-old town of Libkovice once stood.[7] Razed between 1990 and 1998 to let a state-owned company extract coal under the village, the project has since collapsed, leaving former inhabitants fuming.[8]

In the American west, mining activities have long attracted the attention of photographers, though the focus of their interest has proven quite diverse. In the mid-nineteenth century, Carleton Watkins, Timothy O'Sullivan, and others were often commissioned to promote the nascent industry in the hope of luring prospectors and investors. Nowadays, photographers who continue the documentary tradition established by these pioneers are more likely to investigate the environmental impact of mining or its socio-cultural history. Among those

whose practice partakes of both perspectives is Reno-based Peter Goin, who for the last three decades has surveyed the complex relationships between people and the western landscape. Often working in collaboration with other artists and writers, Goin is a well-published observer of the evolving environment. His publications include a trail-blazing study of the nuclear landscape, a rephotographic survey of Lake Tahoe, an exploration of symbiosis entitled *Humanature*, a collaborative documentation of Nevada's Truckee River, called *A Doubtful River*, and an in depth study of mining titled *Changing Mines in America*.

Given the prominence of mining in the western United States, its activities form a recurring theme within Goin's *oeuvre*. In *Humanature*, for instance, Arizona's mammoth Clifton-Morenci Pit, one of North America's largest copper mines, is viewed as a hybrid form of landscape no longer strictly natural, nor entirely manufactured. In contrast, despite thematic and compositional similarities, the photograph of the abandoned Liberty Pit in Ruth, Nevada (plate 30), also an open-pit copper mine, is primarily presented as an historical artifact in *Changing Mines*. Within this context, Goin's focus shifts to the socio-cultural legacy of the mined landscape. Equally breathtaking in its expansiveness is the bird's-eye view of Helms Gravel Pit adjacent to the Truckee River in Sparks, Nevada (plate 31). Ravaged in 1987 by a substantial oil slick flowing from a nearby tank farm, this EPA National Priorities List "Superfund" site has since been cleaned up and given a new vocation. Following stabilization of its banks, the basin has been flooded, stocked with fish, and reinvented as Sparks Marina Park.

If there is one universal icon that symbolizes the industrial processing of our natural resources, it is the smokestack. Within the history of photography, it has been a recurring motif ever since Victor Regnault portrayed the coal-powered plant of the Manufacture de Sèvres on the outskirts of Paris in the 1860s. Made conspicuous by the Pictorialists at the end of the nineteenth century, and later, the icon of the Modernist New Vision between the First and Second World Wars, the theme continues to inspire artists.

In the early 1980s, John Pfahl questioned the threatening proliferation of nuclear power plants and other energy-generating facilities throughout North America. In a series of color images entitled *Power Places*, Pfahl explored the paradoxical relationships between energy production, picturesque landscape, and the alluring forces of the sublime. By 1988, this lyrical alchemist successfully distilled these heterogeneous ingredients in a new way. The resulting *Smoke* pictures, four of which form a part of this exhibition (plates 34–37), retain only the barest hint of the materiality of some towering smokestacks as billows of colorful smoke engulf the pictorial space. Simultaneously attracted and repelled by this "phantasmagoria of light and color," Pfahl conceived these evocative compositions as metaphors of ecological uncertainty.[9] As the current Bush administration radically undermines thirty years of clean-air policy through closed-door legal maneuvers and rule changes, these photographs serve to

remind us that politics remain the most eminent threat to the environment.[10] Ultimately, it is our steadfast denial of such tell-tale signs as the appearance of industrial smog in places as remote as Reno, Nevada (back cover), that will lead our profit-driven society to its ecological demise.

Exclusion Zones

Nowhere is the tragedy of environmental disasters more palpable and irrevocable than in the exclusion zones proliferating around the globe. As the term implies, an exclusion zone is a delimited area into which entry is forbidden. Commonly used to designate military installations, territorial waters, or airspace closed to unauthorized access, the phrase is also a fitting trope to denote ecologically devastated areas that are now unfit for human habitation. Echoing the Judeo-Christian expulsion from the biblical Garden of Eden associated with the Fall of Man, environmentally poisoned exclusion zones are rendered permanently inaccessible by our own doing.

While the individuals, corporations, and governments implicated in these forced evacuations often act with impunity, the testimonies put forth by environmental photographers help to prevent the eradication of their actions from public consciousness. Although photographs, like other forms of representation, are limited in what they can communicate, their indexical relationship with what they represent make them broadly regarded as evidence. Yet, the very toxicity that forces the creation of exclusion zones is often invisible to the eye. From water contamination to ground seepage and from airborne pollutants to radioactivity, there are countless environmental dangers lurking beyond the threshold of visibility. In such cases, all that the photographers can do is to allude, to evoke, or to intimate by means of telling details and signs presented according to their own conceptual framework and philosophical standpoint.

Of all the challenges associated with the depiction of exclusion zones, none has fascinated contemporary photographers more than gauging the impact of nuclear energy upon the landscape and its inhabitants. Following the trend-setting investigations of Kenji Higuchi, Robert Del Tredici, and Peter Goin, other photo-based artists as diverse as Patrick Nagatani, Carole Gallagher, and Lisa Lewenz also began to question the promise of progress implied by the development of atomic energy. By 1987, a collective known as the Atomic Photographers Guild was created. It now counts more than twenty loosely affiliated members, among them David McMillan and Mark Ruwedel, both of whom figure in this exhibition.[11]

On the North American continent, the most contaminated exclusion zone remains the Hanford Nuclear Reservation nestled along the Columbia River in southeastern Washington. Selected in 1943 by the Manhattan Project to house the world's first nuclear reactor, the complex had its ninth reactor shut down in 1991, having by then produced the majority of the plutonium used for the American nuclear weapons program. In the process, the Hanford Works left behind 53 million gallons of plutonium-laden sludge now leaching from disintegrating underground tanks. Hoping "to transform this sludge into glass blocks, where the trapped isotopes would decay harmlessly over 10,000 years," the clean-up is expected to cost "at least $85 billion and last until 2050."[12]

Perhaps prompted by the 1991 publication of Peter Goin's *Nuclear Landscape*, among the first photographic surveys to reveal the harrowing realities of the atomic age, Mark Ruwedel traveled down the Columbia River on three occasions in the early 1990s to document the Hanford Stretch. Favoring an understated, though highly rigorous approach reminiscent of both the New Topographics and their nineteenth-century forebears, Ruwedel brings out the profound dichotomies that now permeate this historical waterway. By portraying the Hanford Stretch as a placid landscape surrounded by a wildlife refuge, an ecology reserve, and a habitat management area, Ruwedel reveals this environmental protectionism as a masquerade. In one diptych taken from a rocky island (plate 53), he represents a two-fold history of forced displacement: on one shore, the abandoned Hanford town site, on the other, the historical meeting ground of a native North American tribe. Once a mighty river, the Columbia is now tamed by three dozen major dams. Electrical pylons, remnants of a bygone era, connect the desolate horizon like a timeline charting the human occupation of the Hanford Stretch.

Seen from the air, as in Emmet Gowin's disconcertingly gorgeous rendition of the Cartesian grid imprinted upon the poisoned riverside (plate 38), Hanford looks as wondrous as the Nazca lines from the coastal plains of southern Peru. How could such beauty belie the unfathomable horror of self-destructiveness? In Gowin's own words, the making of this photograph "changed my whole perception of the age in which I live. . . . What I saw, imagined, and now know, was that a landscape had been created that could never be saved."[13] Once mainly preoccupied with the sensitive portrayal of his immediate family, Gowin has spent the last twenty years drawing inspiration from this disturbing realization. The result has been a sobering compilation of ecological traumas forcing us to contemplate humankind's self-destructive tendency.

This perspective cannot be overlooked as one considers the extensive series Gowin produced at the Nevada Nuclear Test Site, an exclusion zone in both a military and ecological sense of the word. Somewhat easier to access since the end of the Cold War, the highly contaminated 1,350 square-mile testing area located in the Mojave Desert has no parallel anywhere in the world. Created in 1950 as an alternative to the proving grounds of the Marshall Islands in the South Pacific Ocean, the Nevada Test Site has been used for hundreds of atmospheric and underground nuclear explosions. Among the most visually striking features of this forbidden land are the subsidence craters, which are especially numerous throughout Yucca Flat

(plate 20). The result of powerful underground detonations, these hollows and their surrounding areas will remain radioactive for thousands of years. Sedan Crater (plate 40), the largest of them all with a diameter of 1,280 feet, was created in a matter of seconds by a thermonuclear reaction initiated on 6 July 1962. In Gowin's lyrical composition, it assumes a poignant symbolic dimension. As put by the environmental activist Terry Tempest Williams, "Call it a mass grave for all Downwinders or *hibakusha*, as the Japanese refer to 'explosion-affected people.'"[14]

In recent years, the dangers inherent in the production, testing, and application of nuclear energy and their life-threatening effect on people have led a number of photographers to investigate the aftermath of major incidents. Foremost among these studies is Carole Gallagher's extensive documentation of the Nevada Test Site workers, their families, and other "downwinders," who experienced first hand the onslaught of the nuclear clouds that followed every above-ground detonation.[15] By the very nature of her focus on the affected people, Gallagher's *American Ground Zero* stands in sharp contrast to the depopulated spaces featured in this exhibition.

Yet, the void left behind by the forced evacuation of 135,000 people from Ukraine's "Atomic City" of Chernobyl and its surrounding perimeter speaks volumes about human tragedy. Induced by overriding safeguards for testing purposes, the Chernobyl nuclear meltdown, which set one of the reactors aflame for nine days in 1986, let out two hundred times more radioactivity than the amount released upon Hiroshima and Nagasaki. Notwithstanding the thirty-six hour evacuation delay that further threatened countless residents, an exclusion zone fanning thirty kilometers from the epicenter was permanently sealed off to all human occupation. This area encompasses not only thousands of acres of once productive farmland, but also the modern and well appointed community of Pripyat, home to 45,000 employees of the plant and their families. In the course of evacuating, people were forced to abandon all belongings, large and small, for fear of spreading further contamination beyond the zone of total exclusion.

As revealed by David McMillan's photographs taken on a yearly basis since 1994 (plates 45–50), these warnings were only partially heeded. Though evidence of sudden departure remains all pervasive, much has since been removed by too many people oblivious to the invisibility of radioactivity. As time disintegrates the remnants of human occupation and nature reasserts its dominion over the abandoned district, McMillan's expanding archive underscores the dialectic between the half-life of radioactivity and the ephemeral course of civilization. Long after his elegiac portrayal of the once-thriving community has faded beyond recognition, Chernobyl's exclusion zone will remain hopelessly contaminated. As we contemplate such compelling evidence of man-induced ecological disasters throughout *Imaging a Shattering Earth*, it may be wise to remember the fate of Icarus, who refused to obey the voice of reason.

1 Lucy R. Lippard, "Undertones: Nine Cultural Landscapes," in *New American Feminist Photographies*, ed. Diane Neumaier (Philadelphia: Temple University Press, 1995), 39.

2 See Marith C. Reheis, "Dust Deposition Downwind of Owens (Dry) Lake, 1991–1994: Preliminary Findings," *Journal of Geophysical Research-Atmospheres* 102 (27 November 1997): 25999–26008, and Diana Gaston, "Immaculate Destruction: David Maisel's *Lake Project*," *Aperture*, no. 172 (fall 2003): 38–45.

3 Edward Burtynsky, *China: The Photographs of Edward Burtynsky* (Göttingen, Germany: Steidl, 2005), 122.

4 As translated in Gary Michael Dault, "The China Photographs of Ed Burtynsky: Second Sight at the Eleventh Hour," in *Before the Flood: Photographs by Edward Butynsky* (Toronto: Self-published, 2003), 6.

5 Lucas Lackner, "Before the Flood," in *Before the Flood*, 27.

6 Emma Graham-Harrison, "China's Coal Riches Could Ease Oil Insecurity," Reuters News Service, *Planet Ark*, 25 May 2005, http://www.planetark.com/dailynewsstory.cfm/newsid/30962/story.htm.

7 The tragedy behind this series of photographs is recounted in *Emmet Gowin: Changing the Earth* (New Haven, CT: Yale University Art Gallery in assoc. with the Corcoran Gallery of Art and Yale University Press, 2002), 155–57.

8 Jan Haverkamp, "Does a Village Have Rights? Former Inhabitants of Libkovice Want to Buy Back Their Village," *Jinn Magazine*, 1 February 2000, http://www.pacificnews.org/jinn/stories/6.02/000201-czech.html.

9 Artist statement quoted in *A Distanced Land: The Photographs of John Pfahl* (Albuquerque: The University of New Mexico Press, in assoc. with Albright-Knox Art Gallery, 1990), 158.

10 See Bruce Barcott, "Up in Smoke: The Bush Administration, the Big Power Companies and the Undoing of 30 Years of Clean-Air Policy," *New York Times Magazine*, 4 April 2004, cover story (38–45, 66, 73, 76–78).

11 See Blake Fitzpatrick and Robert Del Tredici, *The Atomic Photographers Guild: Visibility and Invisibility in the Nuclear Era* (Toronto: Gallery TPW; Peterborough, ON: The Art Gallery of Peterborough, 2001).

12 Christopher Helman, "Waste Mismanagement," *Forbes*, 18 August 2005, www.forbes.com/2005/08150/035.html.

13 Jock Reynolds, "Above the Fruited Plain: Reflections on the Origins and Trajectories of Emmet Gowin's Aerial Landscape Photographs," in *Emmet Gowin: Changing the Earth, Aerial Photographs* (New Haven, CT: Yale University Art Gallery, in assoc. with The Corcoran Gallery of Art and Yale University Press, 2002), 144.

14 Terry Tempest Williams, "The Earth Stares Back," in *Changing the Earth*, 131.

15 Carole Gallahgher, *American Ground Zero: The Secret Nuclear War* (Cambridge: MIT Press, 1993). Since the Limited Test Ban Treaty was signed by the United States and the Soviet Union in 1963, atmospheric testing of nuclear weapons are no longer permissible.

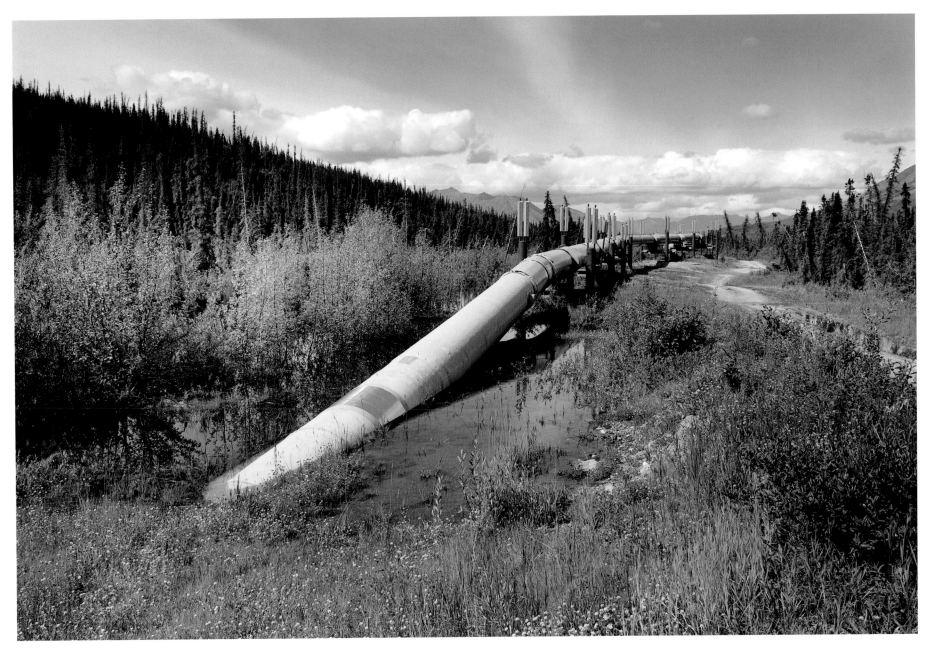

PLATE **21** John Ganis, *Alaska Pipeline, North of Valdez, Alaska*, 2001

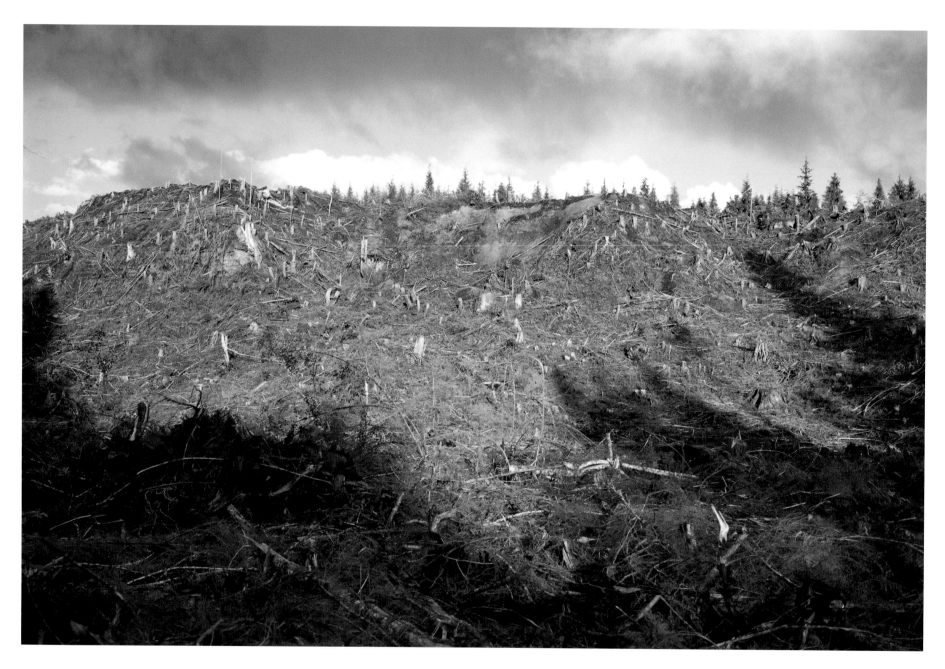

PLATE **22** John Ganis, *Clear Cut in the Hoh Valley, Olympic National Forest, Washington,* 1997

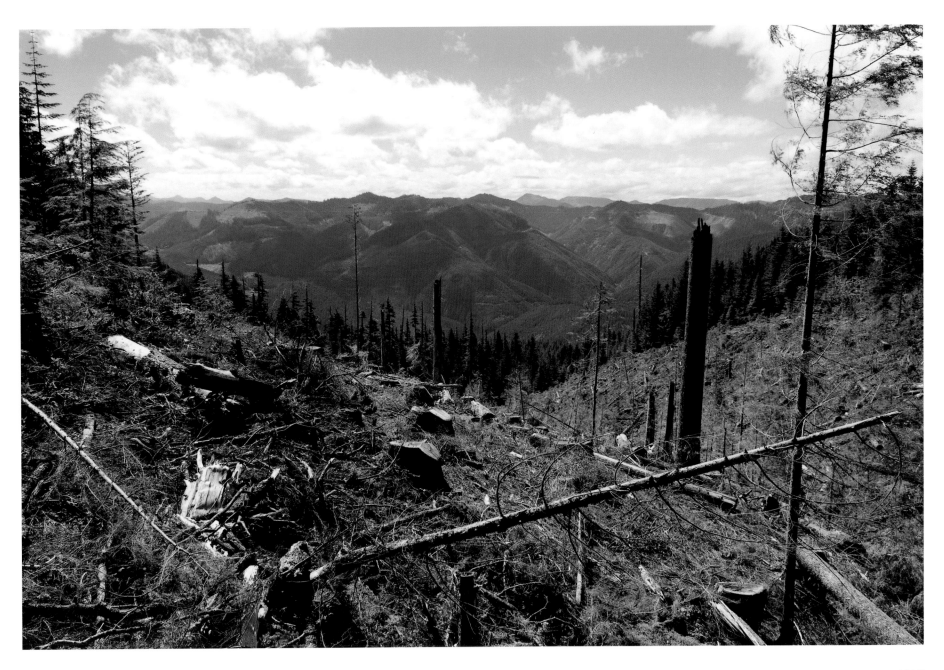

PLATE **23** John Ganis, *Site of a Federal Timber Sale, Willamette National Forest, Oregon,* 1997

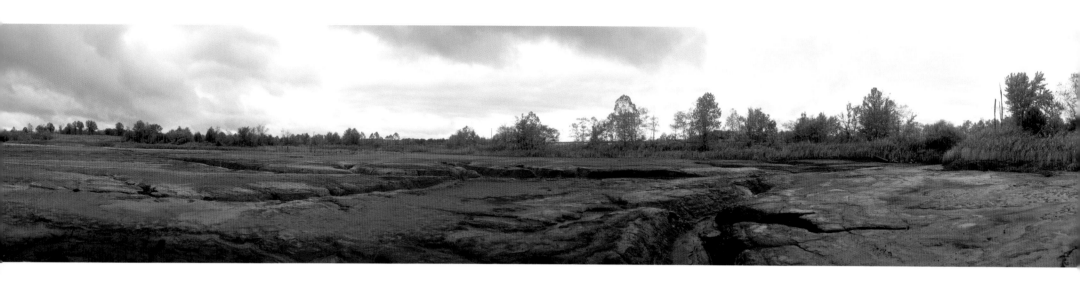

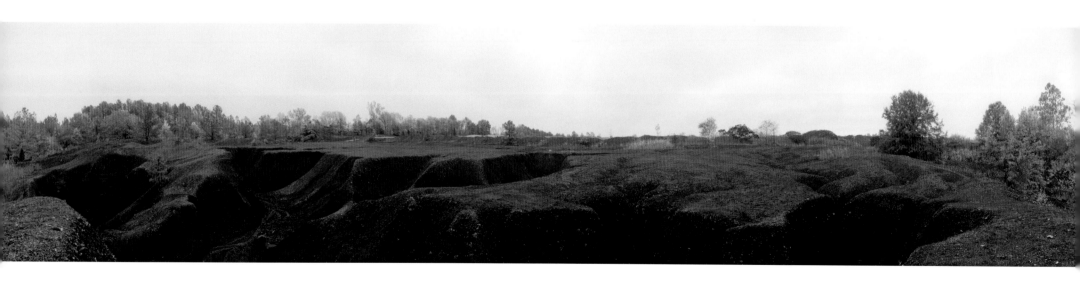

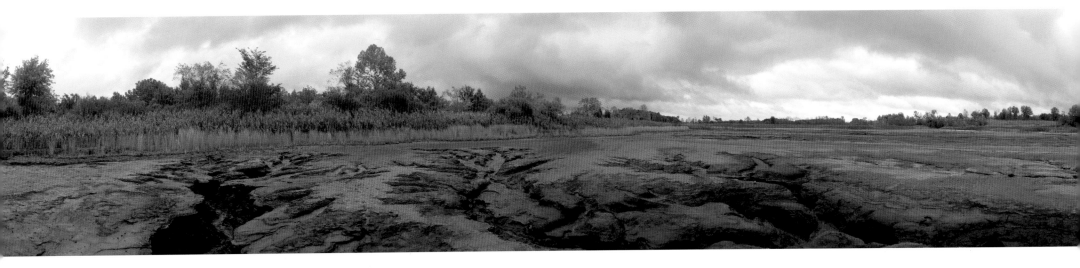

PLATE **24** Jonathan Long, *Orange and Black Cracks,* 2002

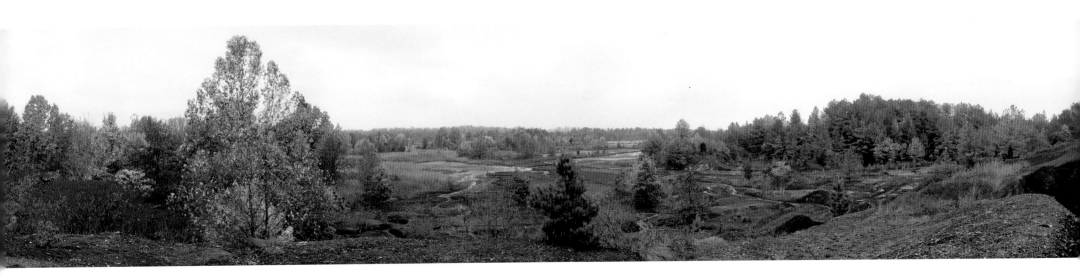

PLATE **25** Jonathan Long, *Fall Colors,* 2002

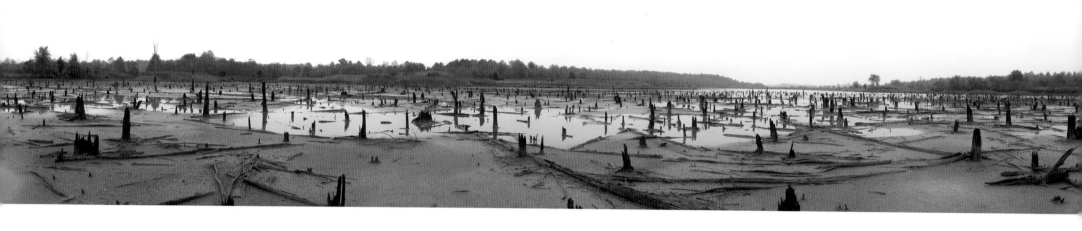

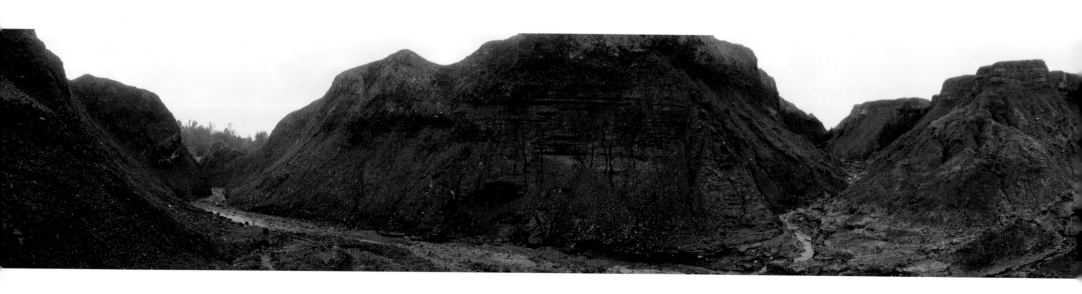

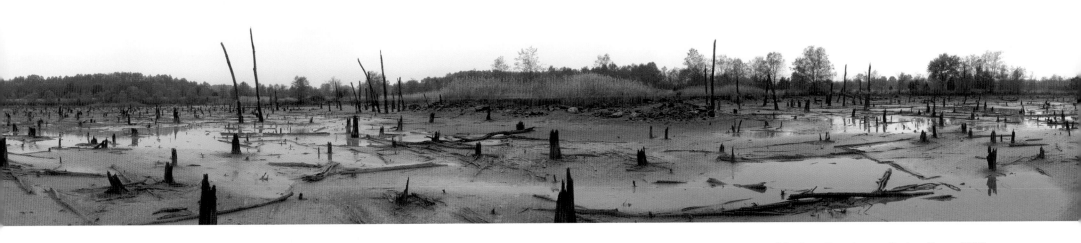

PLATE **26** Jonathan Long, *Broken Trees*, 2002

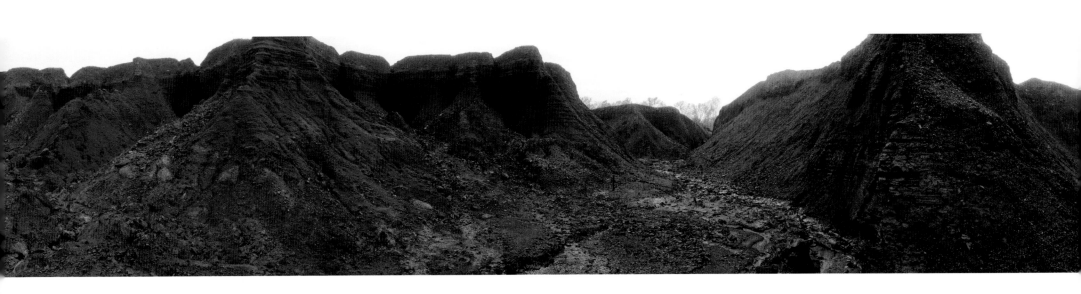

PLATE **27** Jonathan Long, *Black Canyon*, 2002

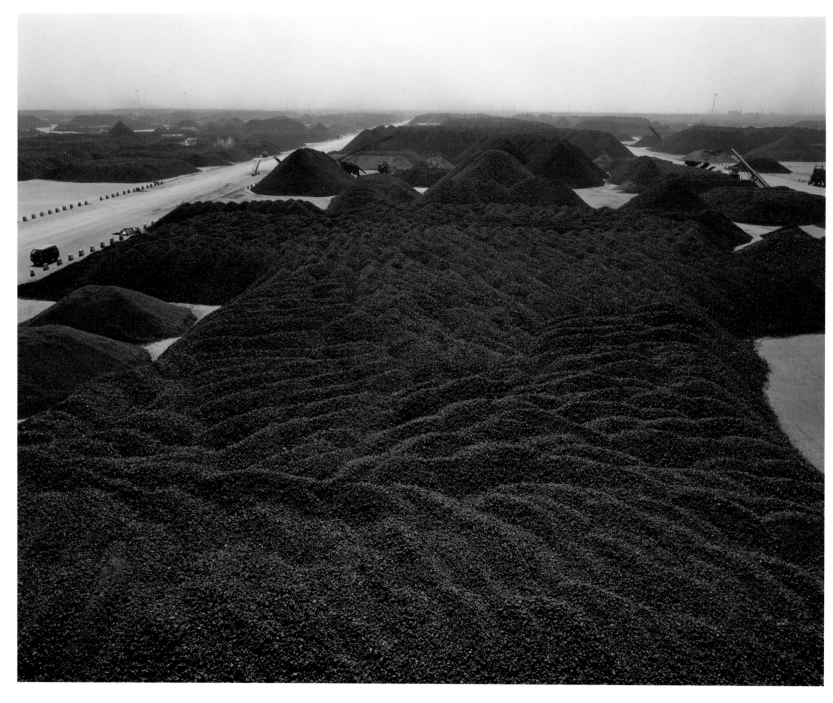

PLATE **28** Edward Burtynsky, *Tanggu Port, Tianjin, China*, 2005

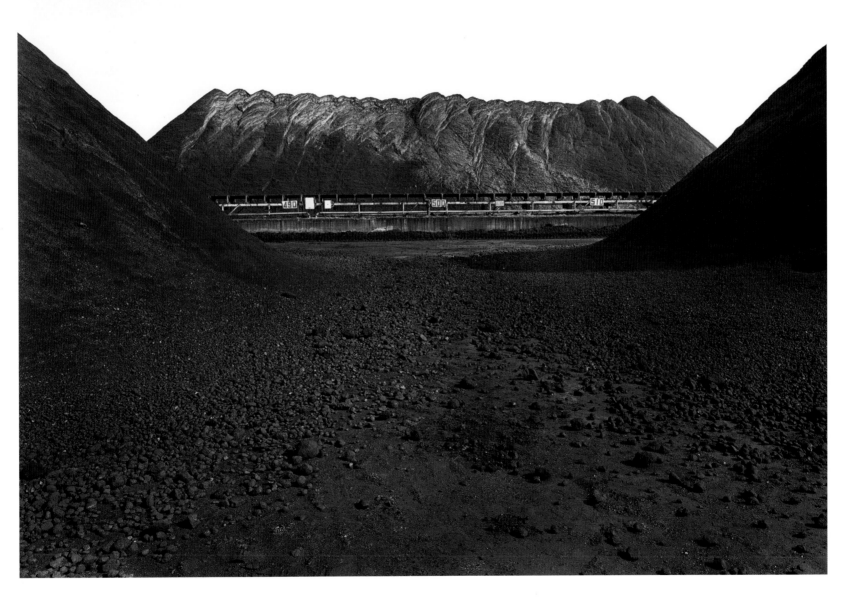

PLATE **29** Edward Burtynsky, *Bao Steel #7, Shanghai, China,* 2005

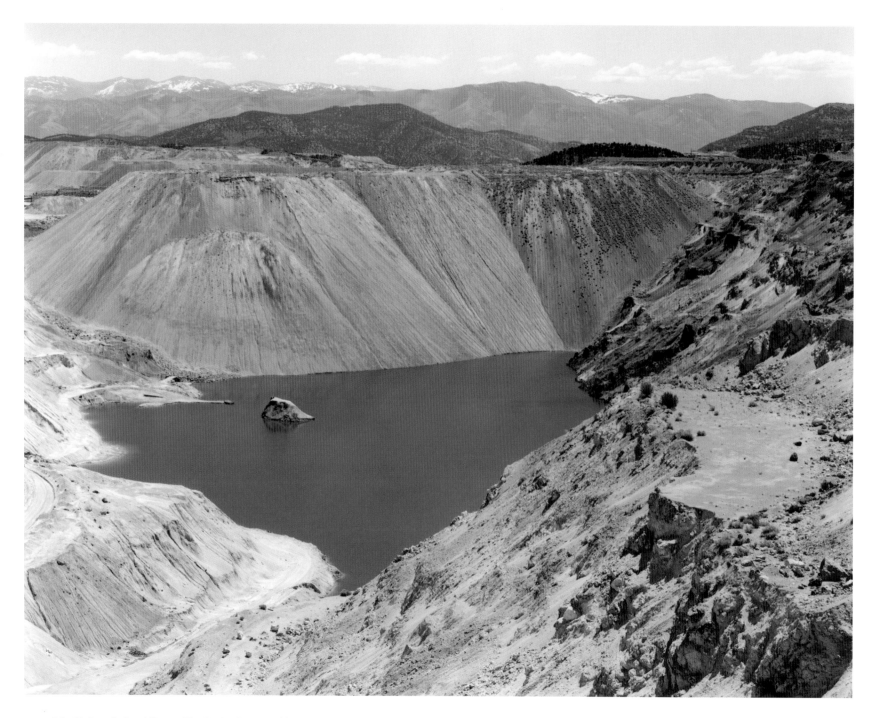

PLATE **30** Peter Goin, *Liberty Pit, Ruth, Nevada*, 1986

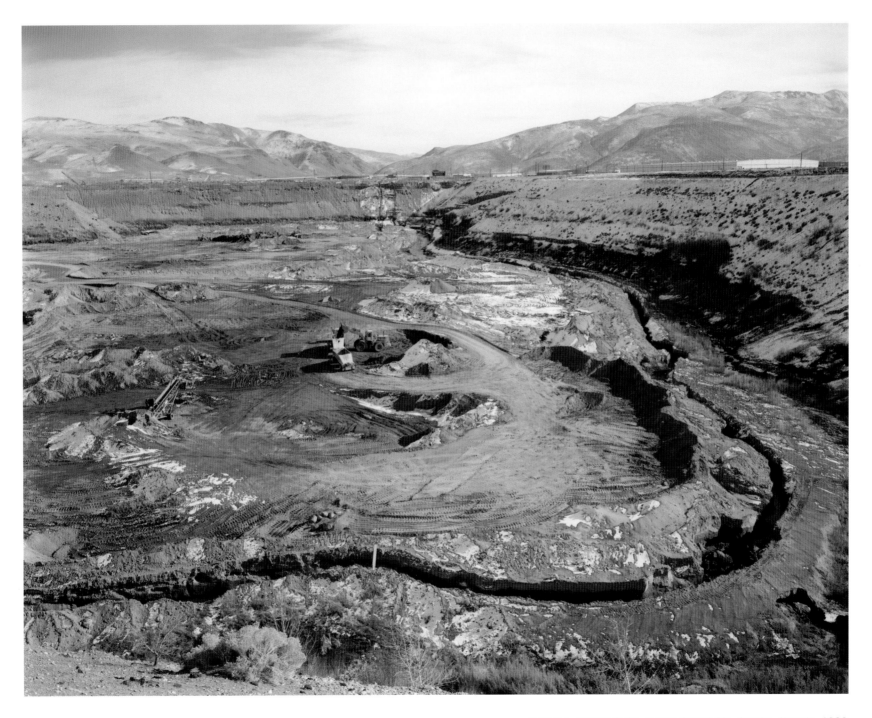

PLATE **31** Peter Goin, *Helms Gravel Pit, Sparks, Nevada,* 1990

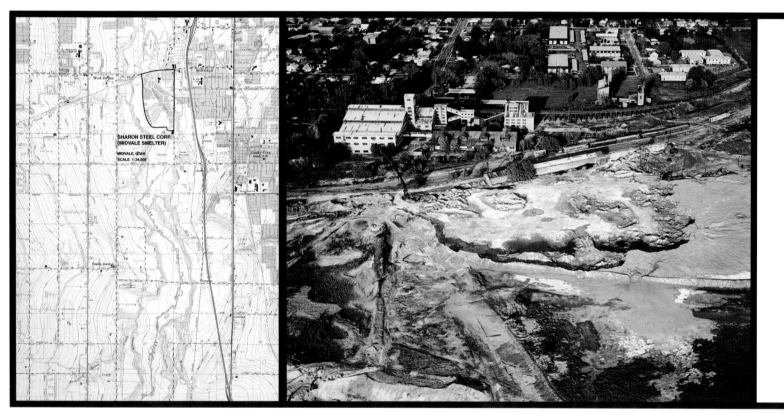

SHARON STEEL CORP. (MIDVALE SMELTER)
Midvale, Utah

Sharon Steel Corp. owns a smelter in Midvale, Salt Lake County, Utah. Midvale (population 10,000) is a part of the Salt Lake City metropolitan area (population 936,000). Metals were smelted and milled on the 260-acre site from about 1910 to 1971. Approximately 10 million tons of mill tailings containing high concentrations of lead, arsenic, cadmium, chromium, copper, and zinc remain on the site. Sharon Steel purchased the site in 1979, intending to reclaim precious metals from the tailings. To date, the only thing the company has done is to sell the pyrite concentrate stored on-site.

Tailings have been blown from the site. In response to dust control ordinances, Sharon Steel has tried to return the material to the tailings pile. Ground water is contaminated with arsenic, zinc, cadmium, lead and chromium, according to analyses conducted by the State, and surface water may be contaminated. About 500,000 people within 3 miles of the site depend on ground water as a source of drinking water.

State and local officials have requested that the company repair its fences and remove gardens planted on the site by residents of nearby apartments. Analyses by the State indicate elevated levels of heavy metals in edible portions of food grown on the site.

U.S. Environmental Protection Agency/Remedial Response Program

PLATE **32** David T. Hanson, *Sharon Steel Corp. (Midvale Smelter), Midvale, Utah,* 1986

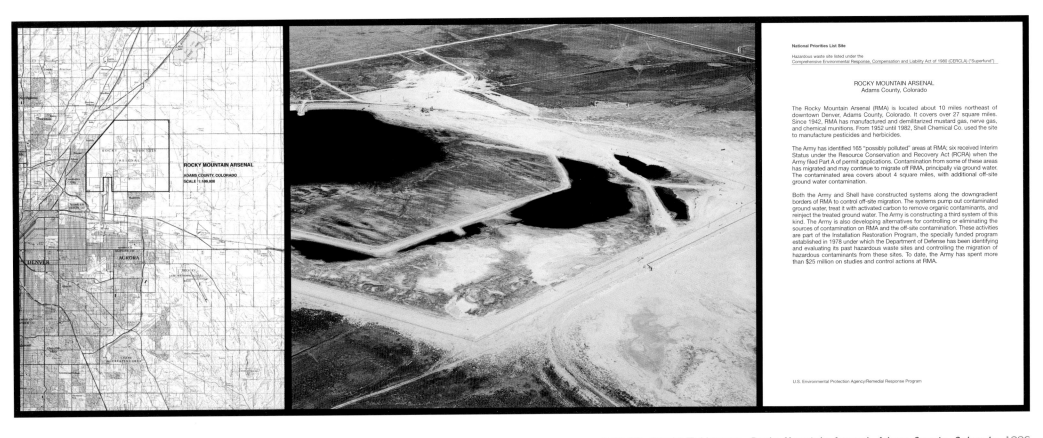

ROCKY MOUNTAIN ARSENAL
Adams County, Colorado

The Rocky Mountain Arsenal (RMA) is located about 10 miles northeast of downtown Denver, Adams County, Colorado. It covers over 27 square miles. Since 1942, RMA has manufactured and demilitarized mustard gas, nerve gas, and chemical munitions. From 1952 until 1982, Shell Chemical Co. used the site to manufacture pesticides and herbicides.

The Army has identified 165 "possibly polluted" areas at RMA; six received Interim Status under the Resource Conservation and Recovery Act (RCRA) when the Army filed Part A of permit applications. Contamination from some of these areas has migrated and may continue to migrate off RMA, principally via ground water. The contaminated area covers about 4 square miles, with additional off-site ground water contamination.

Both the Army and Shell have constructed systems along the downgradient borders of RMA to control off-site migration. The systems pump out contaminated ground water, treat it with activated carbon to remove organic contaminants, and reinject the treated ground water. The Army is constructing a third system of this kind. The Army is also developing alternatives for controlling or eliminating the sources of contamination on RMA and the off-site contamination. These activities are part of the Installation Restoration Program, the specially funded program established in 1978 under which the Department of Defense has been identifying and evaluating its past hazardous waste sites and controlling the migration of hazardous contaminants from these sites. To date, the Army has spent more than $25 million on studies and control actions at RMA.

PLATE 33 David T. Hanson, *Rocky Mountain Arsenal, Adams County, Colorado*, 1986

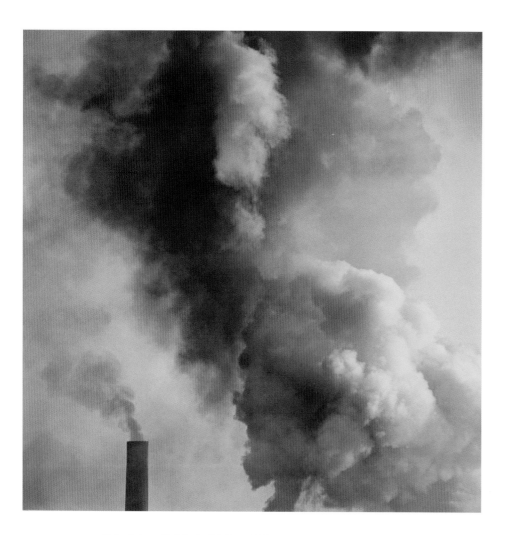

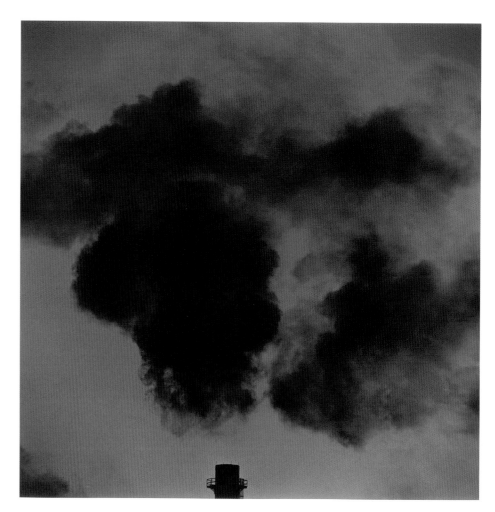

PLATE **34** John Pfahl, *Bethlehem #16, Lackawanna, New York*, 1988

PLATE **35** John Pfahl, *Occidental #18, Niagara Falls, New York*, 1990

46

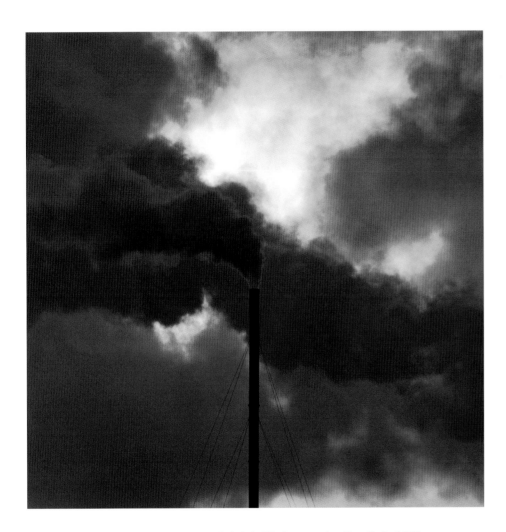

PLATE **36** John Pfahl, *O-Cel-O #7, Tonawanda, New York*, 1989

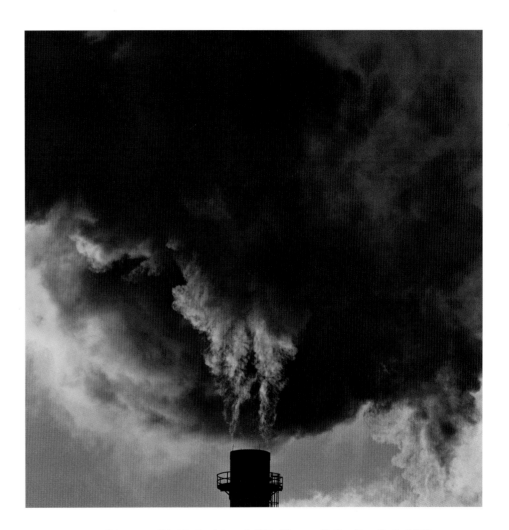

PLATE **37** John Pfahl, *Occidental #75, Niagara Falls, New York*, 1989

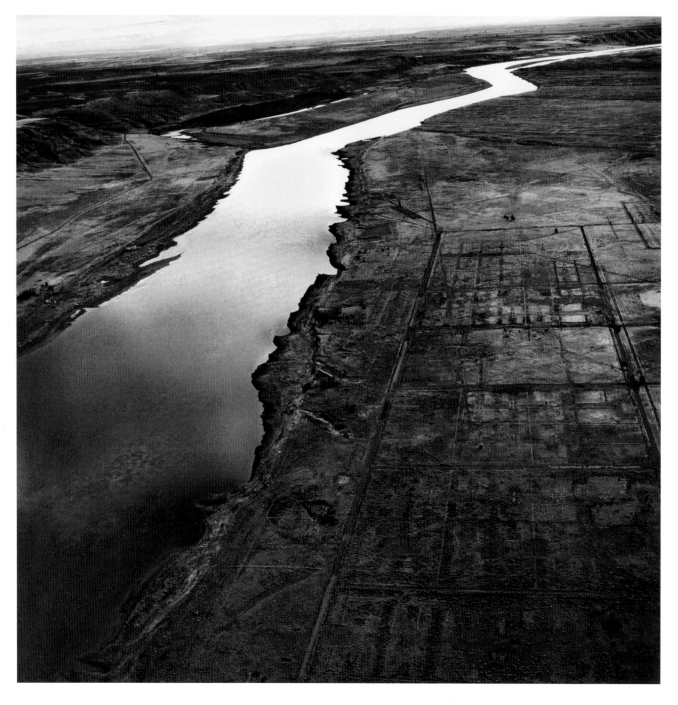

PLATE **38** Emmet Gowin, *Old Hanford City Site and the Columbia River, Hanford Nuclear Reservation near Richmond, Washington,* 1986

Maia-Mari Sutnik
CONTEMPORARY ENVIRONMENTS AND WOMEN PHOTOGRAPHERS

Thirty years ago, the George Eastman House exhibition *The New Topographics: Photographs of a Man-Altered Landscape* (1975), put forth a persuasive statement on the historical predicament of landscape and its changing environment. By presenting the work of eleven photographers, curator William Jenkins opened a new kind of dialogue about the role of industrial culture, specifically in America, by challenging the prevailing ideas about land and the environment.[1] These photographers focused on critical issues affecting the land, like the ephemera of sprawling man-made structures, industrial expansion, and intrusions by exploitive developments. These concerns provided a new context for landscape photography. Embracing the primacy of conceptual analysis—an approach that emphasized photography's descriptive function in a direct and detached manner—the "new topographics" excluded emotional content, stylistic metaphors, and personal traces.

Jenkins's reference to the term "topography" is important as it denotes a specific application: a marked approach that "mapped" the dehumanizing effects of altered environments and reinforced the notion of a neutral or an uninflected "ideal photographic document." This vision provided a counterpoint to the romanticized American sublime—the grandeur of nature commemorated in images of a pristine wilderness inseparable from spiritual values. Ironically, the "new topographics" environments were infused with a strange sense of otherworldly beauty. How strange that desolation and detritus would convey an aesthetic effect, a kind of realist beauty, when the endeavor was intended to produce images without traces of art and artfulness. This may be more telling of photography's transforming quality and how the medium raises questions about its larger role as an objective observer. While the allegiance of the "new topographics" to the precision of nineteenth-century large-format survey photography is evident, it is equally clear that many frontier photographers—who documented much of the American terrain with images appearing impersonal—did not view emerging industries as detrimental to the environment, but as celebrations of man's ingenuity and civilizing effect.

The focus upheld by "new topographics" may be considered an important touchstone to the exhibition *Imaging a Shattering Earth: Contemporary Photography and the Environmental Debate* curated by Claude Baillargeon. This exhibition, with its clearly articulated concept, brings together a select group of photographers, whose works show evidence of man's environmental recklessness. Its distinction from *The New Topographics* is one of conceptual magnitude. By focusing on "the big picture," Baillargeon's goal is to encourage debate

about the progressive, human-induced "shattering" of the earth. In contrast to the artless neutrality or diminishing authorship associated with *The New Topographics*, the emphasis is now on stylistic diversity. Yet, both exhibitions share a preoccupation with measured objectivity.

Beyond the shared exploration of man-altered environments, the most glaring parallel between these two exhibitions remains the largely male dominated representation of photographers. The two sole exceptions being Hilla Becher's contribution (with Bernd) to *The New Topographics* and that of Shana Parke-Harrison (with Robert) to *Imaging a Shattering Earth*. This exclusion of women from the practice of environmental photography could be read in a number of ways. One prevailing view, held by a number of historians and critics, is summarized by Vicki Goldberg: "It is curious how few women count prominently among photographers of the environment. Good ones are not lacking . . . but the emphasis is predominantly male. The landscape has traditionally belonged to men."[2] Another perspective, espoused by art historian and educator Estelle Jussim, views gender neglect as a case of sexism, which only serves to perpetuate gender inequities.[3] Meanwhile, the environmental writer and activist John Grande argues that a male dominated economic system has contributed to historical maleness and femaleness in art. In his view, the patriarchal character of technology and territorialism reflects a structure of closed male ownership of art's subjects.[4] Yet, he provides no clear models for the artistic expressions of "maleness" and "femaleness." For him, answers are to be found in self-discovery and in the observation of an emerging shift in creative values.

The gender disparity then simply provides a hook on which to hang at least one other possible argument in the perceived "absence" of women engaged in contemporary environmental photography. It is not unreasonable to think that certain external factors, such as the challenges posed by physical terrains or the degraded industrial environments of deadly repositories, could privilege male viewpoints. Yet, one could also regard this noted "absence" as a predisposition by women towards alternative environmental values. And the discrete artistic choices to being effective interpreters of the environment may account for a certain disparity in approach to the subject. In which case, one may very well ask: what are the interests of women photographers in the environmental debate?

It should be prefaced that the paucity of women photographers in *Imaging a Shattering Earth* reflects no lack of curatorial effort. Indeed, it would appear that there exists but few works by women that uphold the conceptual parameters of the exhibition. This perplexing situation calls for reflection. If true, could it be an indication that women photographers refuse to view the environmental debate through a lens contingent on inscriptions of objectivity? Or are women photographers preferring to weigh in the debate by means of more personal criteria?

In his essay, Baillargeon clearly notes the presence of various types of environmental photography, an observation that suggests the complexity of the environment as a subject. The intermingling of the terms nature, land, and environment represents a rich source of inspiration with a vast potential for artistic response. Even the formulation of what truly constitutes "an environment" has become an object of debate. Yet, our relationship to the natural world must be the paramount political and social concern of the twenty-first century, as images of Shattering Earth make clear. Meanwhile, the defining parameters of what constitutes "an environmental crisis" remain in flux.[5] Polluted air, contaminated waters, acid rain, vanishing ozone layers, greenhouse gases from smokestacks and car emissions, waste products, deforestation, species decline, all of these imply the need for cleaning up our soil, rivers, swamps, deserts, prairies, and oceans. New ethics are called for if we are to preserve our natural resources and prevent the extinction of livelihoods. Faced with these issues, photographers have the opportunity to respond from varied points of view, including documentary narratives, photojournalism, press reportage, conservancy surveys, formal landscape views, experimental constructions, and other forms of representations tending to be more "sceneographic" than topographic.

Returning to the conceptual frameworks of The New Topographics and Imaging a Shattering Earth, the paucity of work by women in these exhibitions suggests that few of them embrace the visual dicta underlying objectified and depersonalized images of impaired environments. Perhaps more significant for women is the realization that industrial and technological pursuits have very real personal consequences. Thus, both grass-roots documentary and metaphoric approaches are favored by women photographers concerned with environmental issues. Bearing in mind that until the mid-1880s few women ventured to photograph the geographic landscape, it is important to note that by World War I women photographers were "in the field" documenting trenches, debris, and the aftermath of man's inhumanity to man. Just as the societal landscape has changed, so too has our contemporary understanding of landscape—it is no longer specifically geographic, but an aggregate of surrounding conditions and influences affecting our existence. "Landscape" is as much of the cultural and material world as of the elemental world. Clearly, any attempt to examine fully the repertoire of women photographers who have taken up environmental issues is beyond the scope of this essay. However, by considering the strategies of six artists not included in Imaging a Shattering Earth, certain insights into the breadth of possible interpretations of long-term consequences of human-induced damages come to light.

Notwithstanding Barbara Norfleet's Nevada Test Site: 1350 Square Miles (1991), presenting simulated town dwellings in which nuclear devices have exploded, and Lisa Lewenz's disturbing views of the Three Mile Island nuclear reactors (1984), few women have explored nuclear issues in photographic terms. Those that do, however, like Carole Gallagher, have not adopted the detached critical and artistic modes manifested in the work of their male counterparts. Nonetheless, women photographers are mindful of the enormity of the subject, and for her part, Sharon Stewart has provided a critical perspective on the hazards of radioactive waste in an exceptionally telling project.

Stewart's A Toxic Tour of Texas (1992), addresses the concentration of oil refineries, chemical plants, nuclear weapons, and uranium processing facilities in Texas, all of which release unprecedented levels of carcinogens into the environment, endangering the lives of local inhabitants. Stewart's critical fact-finding testimonial approach culminated in a photographic narrative on the environmental dangers generated by corporate greed. Her indictment of corporate-induced environmental degradation adopts the strategies of photojournalism and personal rapport, rather than that of an anonymous witness. Giving voices and faces to the lives compromised by uncontrolled toxic disposal, Stewart provides us with ample evidence of this ongoing disaster.

Another personal take on environmental abuse is found in the work of Canadian photographer Ruth Kaplan. Her casual images of garbage and debris in a metropolitan environment are more than a mere "slap on the hand" for poor public etiquette. Instead, they highlight a recognizable pattern of urban crisis that impacts our daily lives. The implicit message of Kaplan's subtext is the manufacturing of excess. Clusters of debris including plastics, newsprint, packaging, bottles, etc., draw attention to our diminished capacity to deal with the excess resulting from the overproduction of goods, a situation disguised by manufacturers as "consumer needs." Appearing in Toronto Life magazine in May 2000, Kaplan's work is not merely an exposé on a despoiled urban environment, but also a critique of the consuming constituency.

Another concern related to the environmental debate is the reclamation of resources. Ruthe Morand's contribution to the Central Arizona Project (1986) details salient aspects of one of the world's major canal developments, which was built in the Sonoran Desert to provide water and economic growth.[6] Captured by means of a frank and unadorned documentary style, Morand's views center on the concrete walls extending far into the horizon and the gigantic construction equipment. Completed in 1986, the canal's builders claimed it to be carefully engineered, but questions remain as to whether the 330-mile canal and its pumping plants, tunnels, and electric transmissions equipment will eventually prove detrimental. While Morand's photographs do not directly question the moral implications and inequities of the project, they do show how the structure has profoundly changed the desert environment. In addition, they can be viewed as metaphors for the battles opposing monetary gains and environmental concerns.

Equally relevant is the work initiated some twenty-five years ago by Terry Evans, who deals with a wider repertoire of environmental observations and is motivated by formal experiments that include aspects of performance. Her concentration on prairie sites may at first be perceived as a mere formal strategy to capture mesmerizing and tangled textures, but such abstractions of visible and invisible effects engage larger questions of presence and absence. Her aerial investigations of the prairies bring to the fore historic scars, signs of abandonment, incursions, and cultural patterns. An extension of her work is found in the collecting, classifying, and photographing of prairie botanical specimens. Evans's project also involves the actual return of specimens to their indigenous places. The act of correcting prairie ecology, for example, includes the re-introduction of the once free-roaming bison to the Tallgrass Prairie Reserve. Within Evans's work, this practice exemplifies a remedial response to the causalities of human intervention.

Preservation, rescue, and conservancy are also part of women's response to environmental issues. Patricia Layman Bazelon's gritty photographs from the late 1980s and early 1990s, which document the monumental grain elevators of Buffalo, New York, represent a desire to rescue the heroic symbols of the 1920s from the wrecker's ball and to re-purpose their use. It is a task that seems replete with irony when taking into account the legacy of these towering industrial structures, which once upon a time stressed the frail infra-structures of urban environments. Bazelon's images are a wry comment on social memory, on historical heritage, and on the ability of photography to preserve symbols of past industrial environments.

Though not normally thought of as an environmental photographer, Mary Ellen Mark—a documentary artist known for her revealing portraits capturing the hardship, suffering, and innocence of diverse cultures—deals squarely with environmental degradation. For it is only upon examining the locales she photographs that one becomes aware of how environmental issues intersect with her subjects. Her subjects inhabit places with corrosive ecologies, where the prevailing socio-economic realities and contradictions are due to corporate exploitation. Shattered environments—places compromised by industrial hazards, poisoned air, contaminated water, and unanticipated natural disasters—are the essence of Mark's images. Her documentation in 2000 of the social reality of the coastal people on the remote Delmarva Peninsula is a devastating statement. Here, family farms overtaken by large-scale industry and the loss in small fishing ventures to commercial fleets has reduced the community's ability for self-reliance to bare survival—all due to industries encroaching on these inhabitants' harmony with their natural environment.

It would appear from the issues addressed above that women are full participants in the environmental debate. Commenting on the social and cultural histories of land, industry, effects of degradation, issues of remedial action, and environmental conservancy, they examine important environmental questions. In the process, they adopt a variety of approaches and styles, especially self-directed documentary narratives and journalistic modes of critical inquiry. In contrast to the works included in *Imaging a Shattering Earth*, the environmental contributions of women photographers appear less concerned with the practice of "mapping" environments or the desire to assume critical distances. On the contrary, their observations stem from a driving force that regards impaired environments as part and parcel of sociological relations, which foster a more intimate or personal awareness of issues. Such approaches can, and do, produce critically enduring images. As Martha Sandweiss argues in *The Country Between Us:* "Rather than viewing the natural world as a thing apart—an unapproachable deity, and overwhelming physical force, a world whose inherent moral value is only defiled by human contact—[women] have tended to focus on the symbiotic relationship between humans and their environment."[7]

If there is a declared vision for women photographers engaged in the environmental debate, it is clearly not that manifested by the "ideal document," nor is it aligned with the conceptual approaches featured in *Imaging a Shattering Earth*. There are, of course, many women photographers observing and exploring the environment by means of critical strategies not discussed here—one think, for example, about Wanda Hammerbeck, Barbara Bosworth, Paula Chamlee, Virginia Beahan, Lynda Butler, and Laura McPhee. Clearly their work also represents a wealth of images concerned with industrial presence. Yet, none entirely fulfill Baillargeon's exhibition criteria. However, it must be acknowledged that our far-reaching neglect and disregard for the environment has been addressed by several women photographers working from varied aesthetic and critical perspectives. While the global narrative of our plagued environment has not been played out in full, there are signs of consequences to be found everywhere. *Imaging a Shattering Earth* is but one of the powerful ways to examine the paradox that reveals itself as both a psychic and physical reality.

1 The included photographers were Robert Adams, Lewis Baltz, Bern and Hilla Becher, Joe Deal, Frank Gohlke, Nicholas Nixon, John Schott, Stephen Shote, and Henry Wessel,Jr.

2 Vicki Goldberg, *ARTnews*, summer 1991, quoted in *The Country Between Us: Contemporary American Landscape Photographs* (Boston, MA: Huntington Gallery, Massachusetts College of Art, 1992).

3 Estelle Jussim review in *VIEWS: The Journal of Photography in New England*, summer 1992, 16–17.

4 John K. Grande, *Balance: Art and Nature* (Montreal: Black Rose Books, 1994), 75–77.

5 David Quammen, "Planet of Weeds," *Harper's* 297 (October 1998).

6 Robert Walsh and William Jenkins, *Central Arizona Project* (Arizona: Center for Creative Photography, 1986), 10–11.

7 Quoted in *VIEWS*, summer 1992, 16.

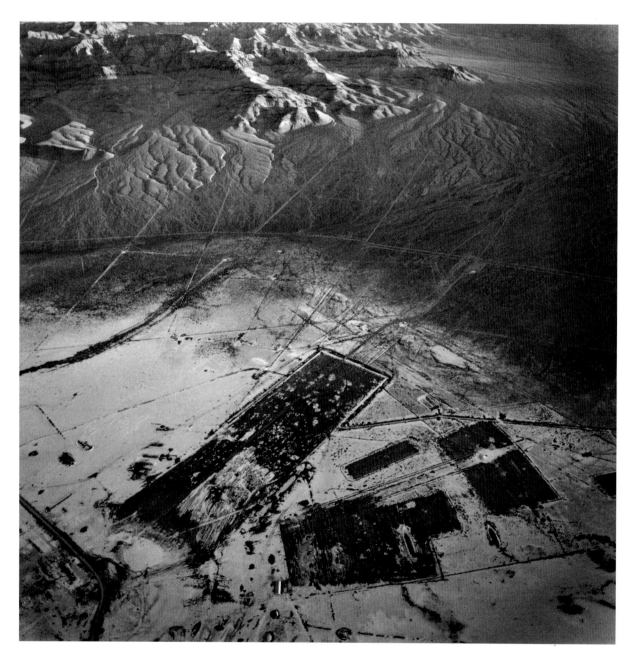

PLATE **39** Emmet Gowin, *Line of Sight Markings and Areas Cleared of Radioactive Soils, Frenchman Flat, Nevada Test Site*, 1996

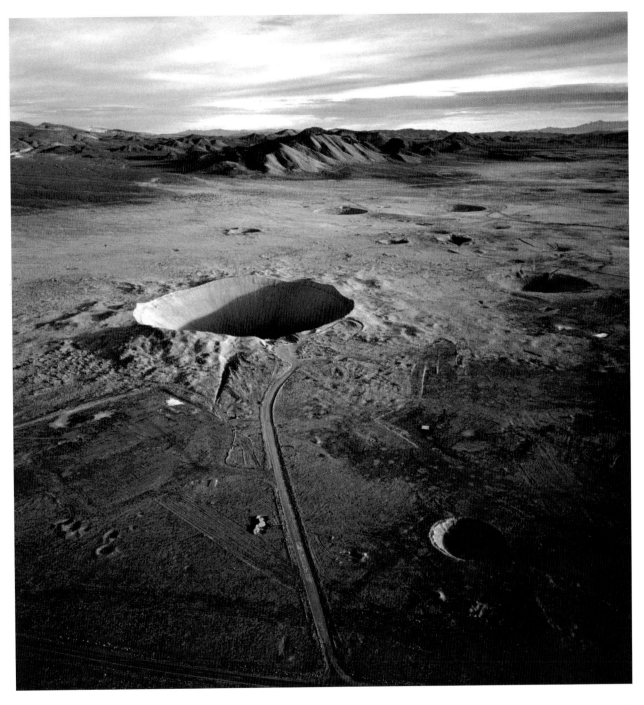

PLATE **40** Emmet Gowin, *Sedan Crater, Area 10, Northern End of Yucca Flat Looking South, Nevada Test Site,* 1996

PLATE **41** **Emmet Gowin,** *Air Exhaust Shaft and the Razed Village of Libkovice in a Poisoned Landscape, Bohemia, Czech Republic,* 1992

PLATE **42** Emmet Gowin, *The Abandoned and Condemned Village of Times Beach, Missouri,* 1989

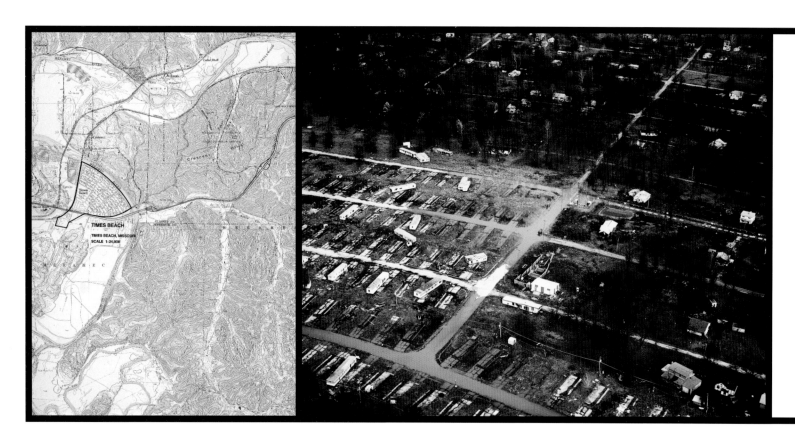

National Priorities List Site

Hazardous waste site listed under the
Comprehensive Environmental Response, Compensation and Liability Act of 1980 (CERCLA) ("Superfund")

TIMES BEACH
Times Beach, Missouri

The city of Times Beach (population 2,800) covers 8 square miles on the floodplain of the Meramec River in St. Louis County, Missouri. In 1972 and again in 1973, the city contracted with a waste oil hauler to spray oil on unpaved roads for dust control. It was later learned that the waste oil contained dioxin. In November and early December 1982, EPA sampled the roads and right-of-ways in Times Beach. Soon afterward, the Meramec River flooded the city. EPA expedited the sample analyses and found dioxin at levels from less than 1 part per billion (ppb) to 127 ppb. As a result, the Centers for Disease Control (CDC) issued a health advisory on December 23, 1982, recommending that people relocated from Times Beach due to flooding should stay away, and that those remaining should leave. EPA resampled the area in January 1983 to determine if flood waters had deposited contaminated soil into homes and yards. In the second week of January, EPA allocated $500,000 to CDC to collect health questionnaires and examine the people of Times Beach. On February 22, 1983, EPA pledged $33 million from Superfund to purchase the Times Beach property under a relocation plan to be developed and implemented by the Federal Emergency Management Agency.

EPA is preparing a Remedial Action Master Plan outlining the investigations needed to determine the full extent of cleanup required at Times Beach. The next step is a feasibility study to identify alternatives for remedial action. CDC will continue its questionnaires and examinations and is also working with EPA to define cleanup levels for dioxin at Times Beach.

U.S. Environmental Protection Agency/Remedial Response Program

PLATE **43** David T. Hanson, *Times Beach, Missouri,* 1985

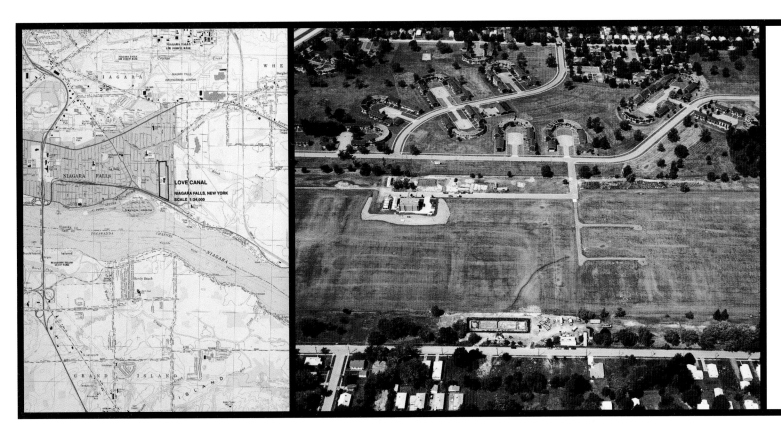

LOVE CANAL
Niagara Falls, New York

Love Canal is a 16-acre landfill in the southeast corner of the city of Niagara Falls, New York, about 0.3 miles north of the Niagara River. In the 1890s, a canal was excavated to provide hydroelectric power. Instead, it was later used by Hooker Electrochemical for disposal of over 21,000 tons of various chemical wastes. Dumping ceased in 1952, and in 1953 the disposal area was covered and deeded to the Niagara Falls Board of Education. Extensive development occurred near the site, including construction of an elementary school and numerous homes.

Problems with odors and residues, first reported at the site during the 1960s, increased in the 1970s as the water table rose, bringing contaminated ground water to the surface. Studies indicate that numerous toxic chemicals have migrated into surrounding areas. Run-off drains into the Niagara River at a point 2.8 miles upstream of the intake tunnels for Niagara Falls' water treatment plant, which serves about 77,000 people. At this discharge point, the river sediment has also become contaminated.

Between 1977 and 1980, New York State and the Federal government spent about $45 million at the site: $30 million for relocation of residents and health testing, $11 million for environmental studies, and $4 million for a demonstration grant (under the Resource Conservation and Recovery Act) to build a leachate collection and treatment system.

A study completed in 1982 recommended construction of a slurry wall and cap to contain ground water in the site as the long-term solution.

In July 1982, EPA awarded a $6,995,000 Cooperative Agreement to New York for (1) construction of a slurry wall and cap, (2) four feasibility studies, and (3) a long-term monitoring study to determine seasonal variations in ground water levels and leaching. In September 1982, $892,800 was added to (1) demolish the school, (2) install a synthetic membrane over a temporary clay cap, and (3) erect a fence.

The Department of Justice, on behalf of EPA, has brought a federal civil action seeking injunctive relief against parties potentially responsible for wastes associated with the site.

PLATE 44 David T. Hanson, *Love Canal, Niagara Falls, New York,* 1986

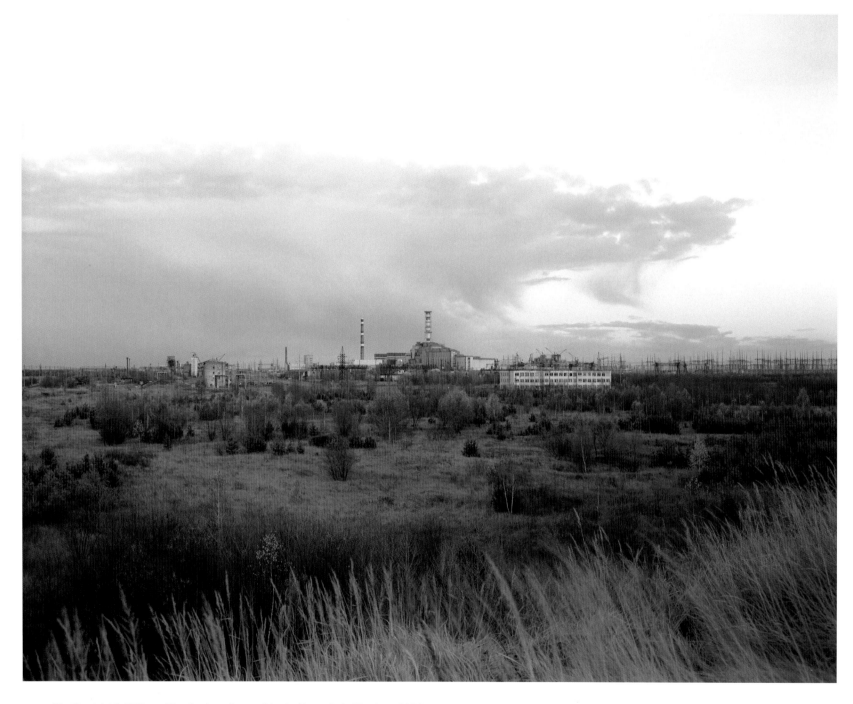

PLATE **45** David McMillan, *The Nuclear Power Plant, Chernobyl, Ukraine*, 1998

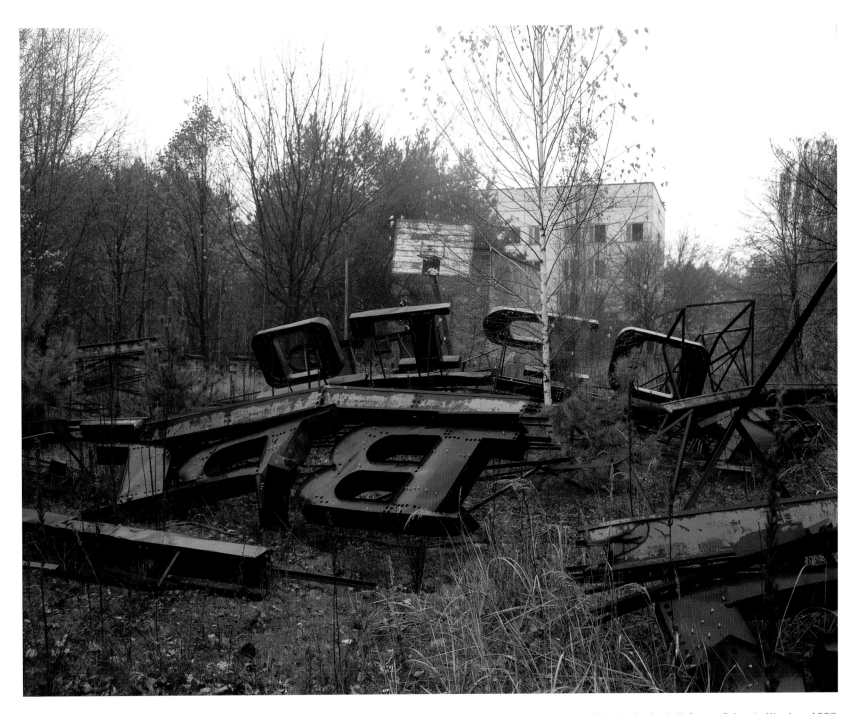

PLATE **46** David McMillan, *Roof Sign in Basketball Court, Pripyat, Ukraine,* 1998

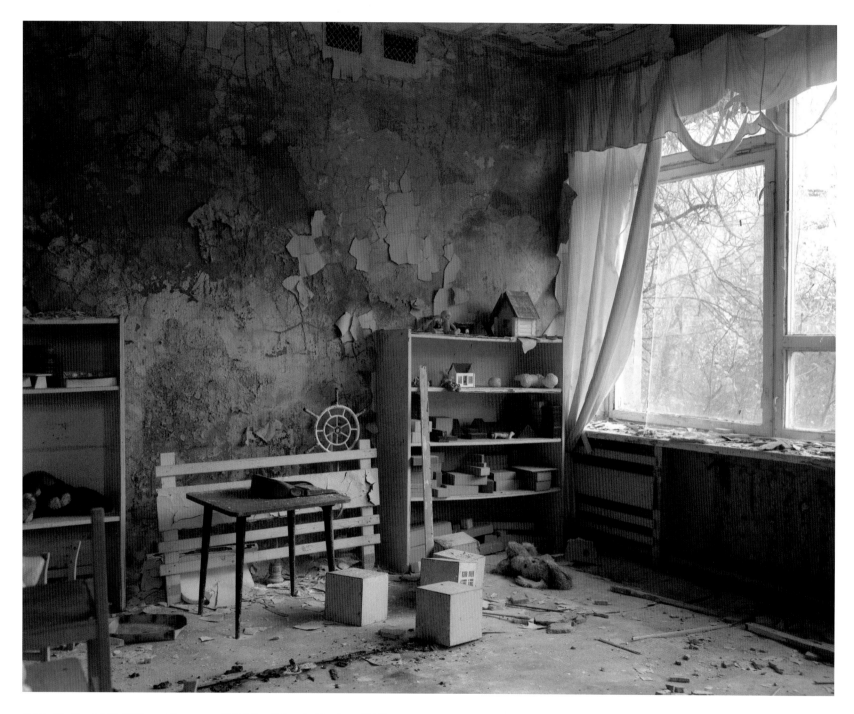

PLATE **47** David McMillan, *Classroom Still Life, Pripyat, Ukraine*, 1997

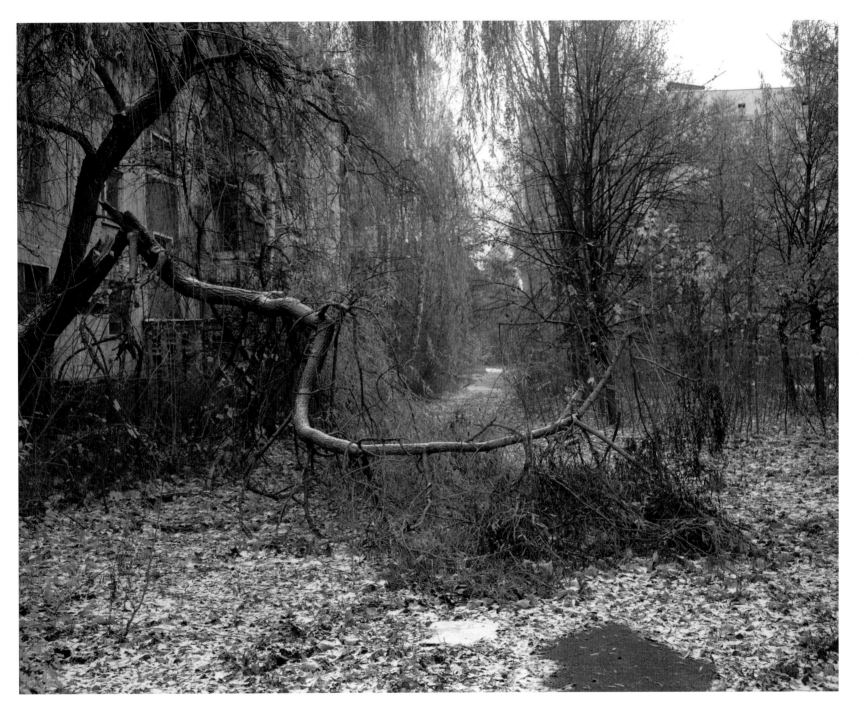

PLATE **48** David McMillan, *Broken Tree, Pripyat, Ukraine,* 1997

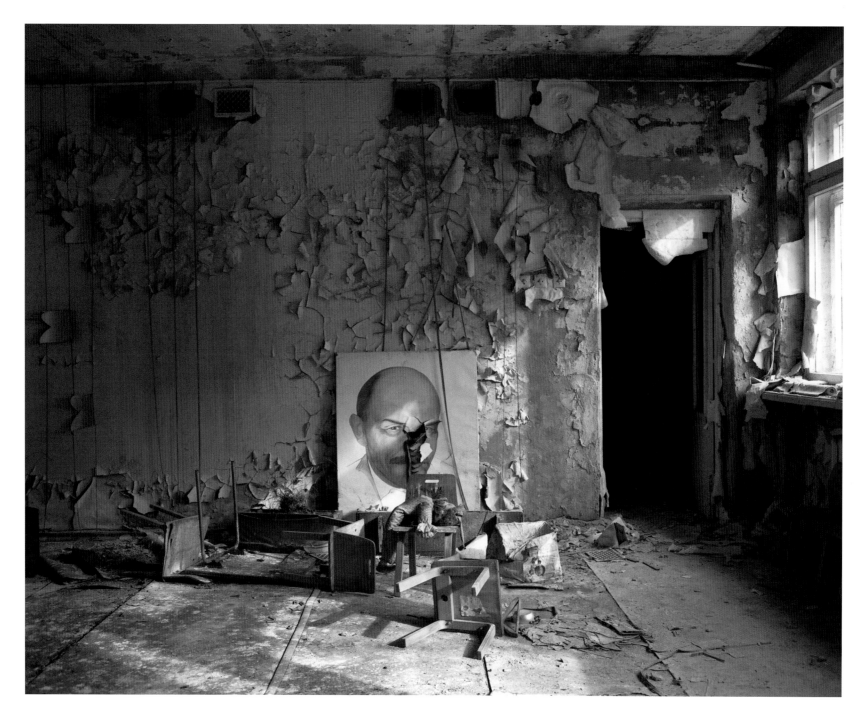

PLATE **49** David McMillan, *Portrait of Lenin, Pripyat School, Ukraine,* 1997

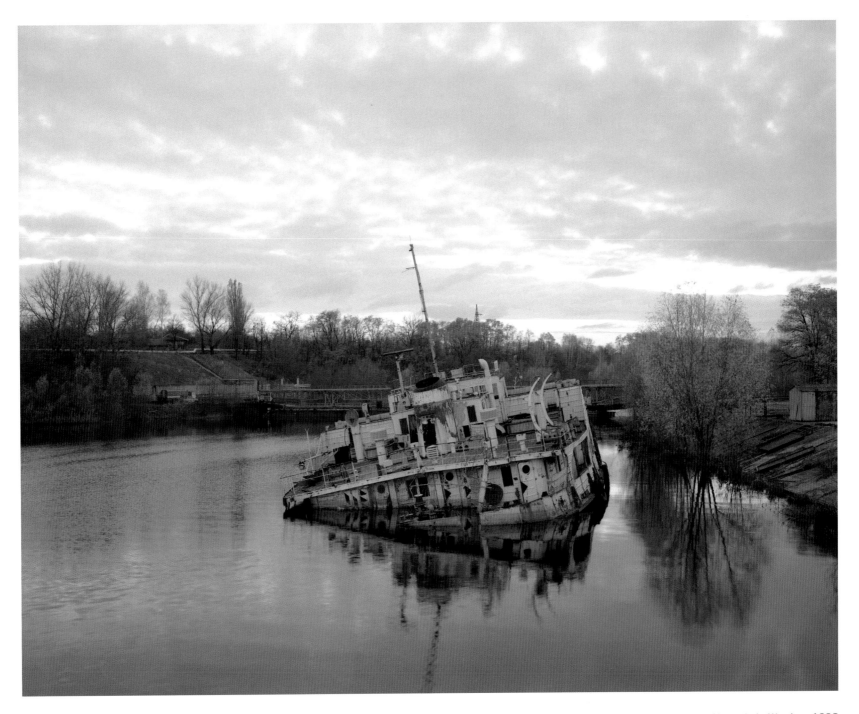

PLATE **50** David McMillan, *Sinking Boat, Chernobyl, Ukraine,* 1998

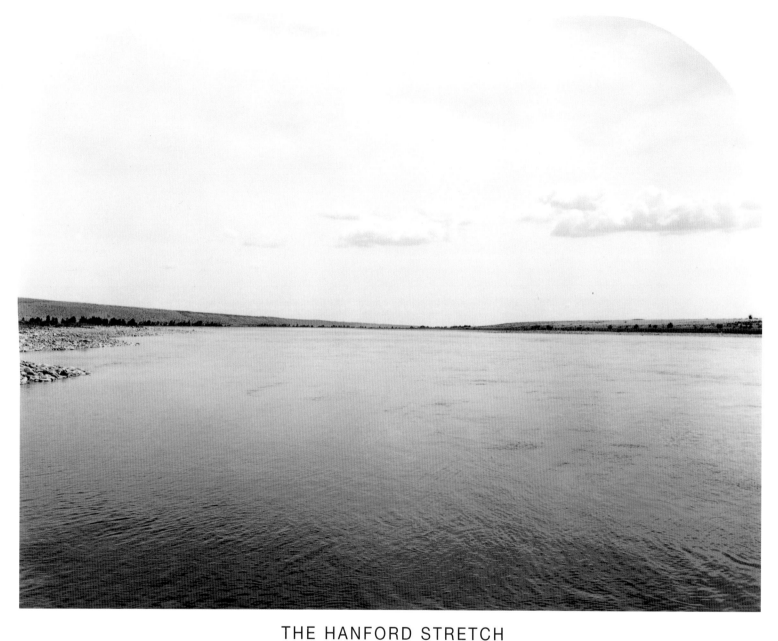

THE HANFORD STRETCH

SADDLE MOUNTAIN
NATIONAL WILDLIFE REFUGE

HANFORD WORKS
U.S. DEPT. OF ENERGY

PLATE 51 Mark Ruwedel, *The Hanford Stretch*, 1992–93

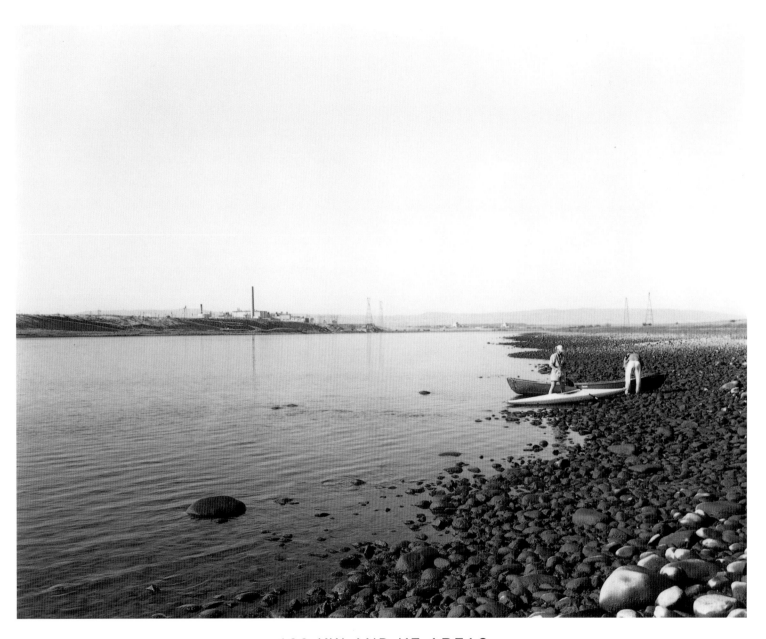

100 KW AND KE AREAS
(BREAKING CAMP, EARLY MORNING)

PLATE **52** Mark Ruwedel, *The Hanford Stretch*, 1992-93

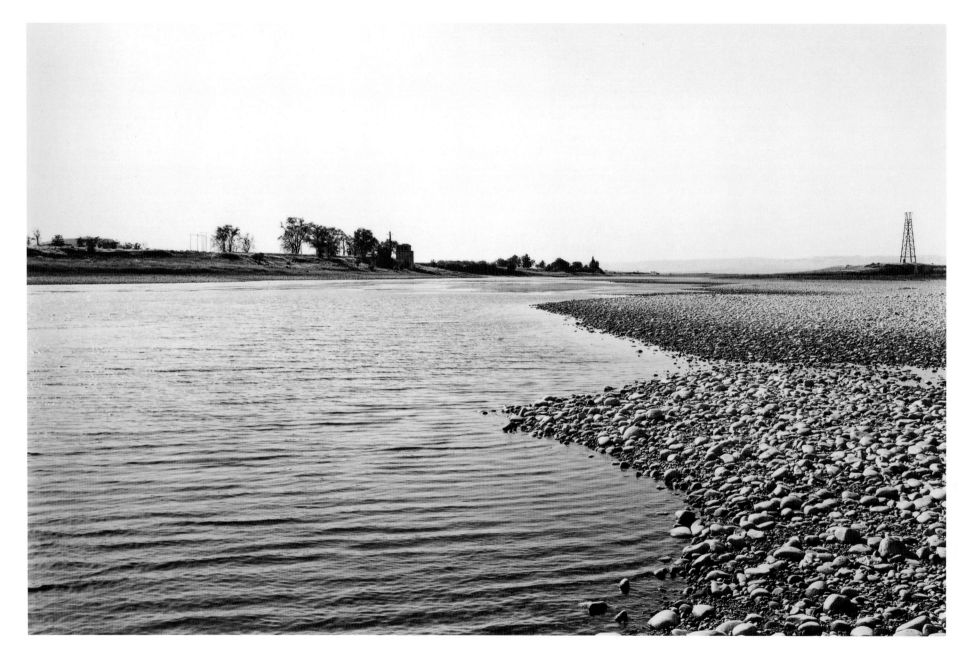

HANFORD TOWN SITE

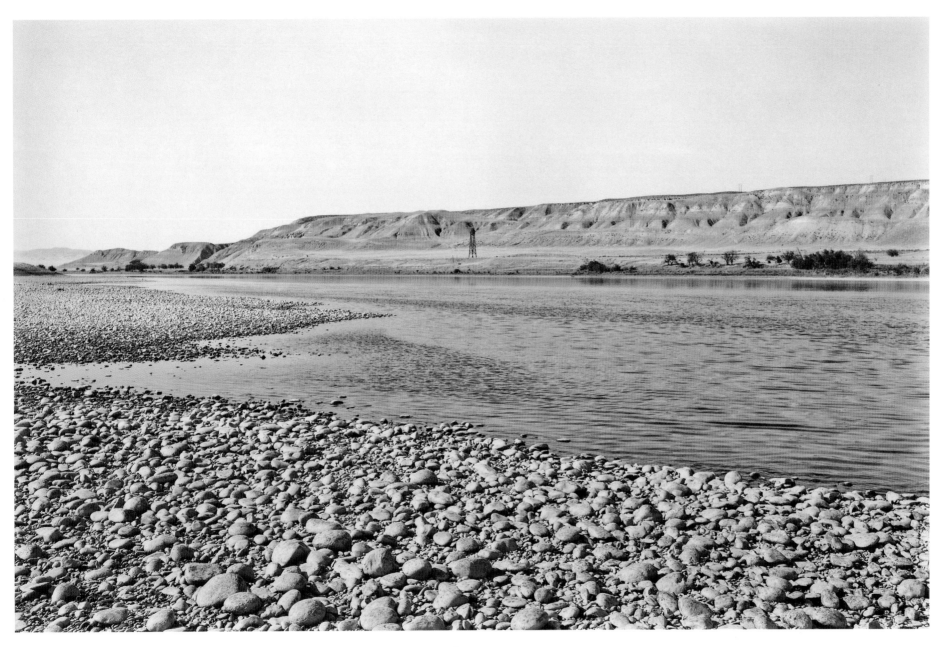

A NEZ PERCÉ MEETING PLACE

PLATE **53** **Mark Ruwedel,** *The Hanford Stretch,* 1992–93

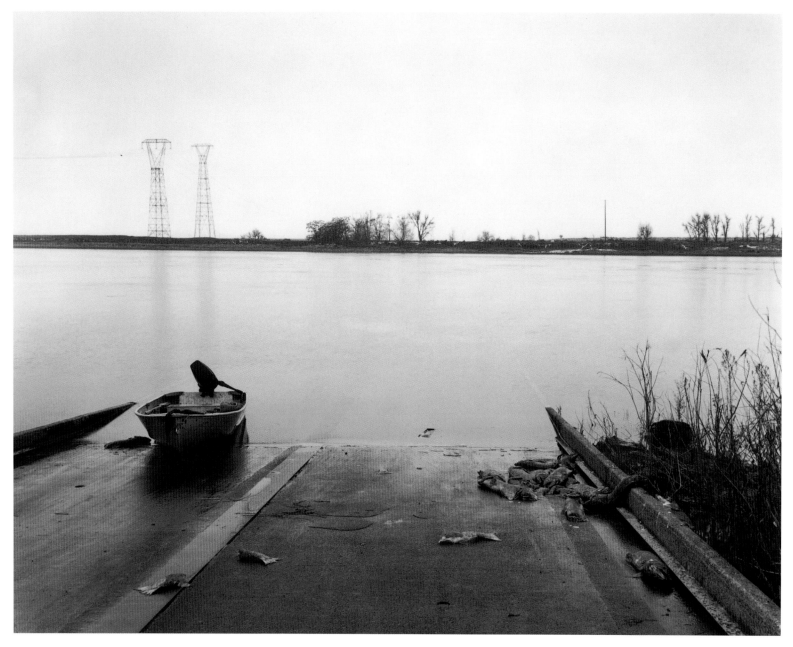

EAST WHITE BLUFFS FERRY SITE
(STEVE'S BOAT/DEAD CHINOOK)

PLATE **54** Mark Ruwedel, *The Hanford Stretch*, 1992–93

All works lent by the artists unless otherwise stated. Dimensions are approximate. Selected bibliographies follow entries.

EDWARD BURTYNSKY
born St. Catherines, ON, 1955 I resides Toronto, ON

Four digital chromogenic prints from *China*, 2002–05, ranging in scale from 48" x 60" to 22" x 87."

Edward Burtynsky has spent twenty-five years tracking interrelated forms of land use including mining, drilling, manufacturing, and recycling. His recent work deals with the environmental consequences of China's current socio-economic revolution. Beginning in 2002, Burtynsky photographed the massive demolitions related to the Three Gorges Dam hydro-electric project. Located on the Yangtze River, the completion of the world's largest dam system will result in the flooding of one of China's greatest fertile valleys thereby displacing over one million people and destroying the fruit of 5,000 years of civilization. Whole cities are being dismantled and moved, brick by brick, forcing people to leave behind ancestral land, livelihoods, and multi-generational communities. A further consequence of this displacement is the huge influx of rural populations into the urban centers, where cheap labor is already abundant. Such conditions have lead to the rapid growth of the building industry, ramping up China's steel consumption to all time highs. Shanghai Bao Steel Group, a state-owned company, is the leading domestic producer with 15,600 employees. Fueling that production is some of the dirtiest coal on earth. At the very moment when many developed nations are looking for alternatives, China is now tapping into its reserves containing an estimated "trillion tons of (low-grade/ high sulphur) coal" (quoted in *China*, 141).

Burtynsky, Edward. *Before the Flood.* Toronto: Self-published, 2003.
_____. *China: The Photographs of Edward Burtynsky.* Göttingen, Germany: Steidl, 2005.
Pauli, Lori. *Manufactured Landscapes: The Photographs of Edward Burtynsky.* Ottawa: National Gallery of Canada, in assoc. with Yale University Press, 2003.
www.edwardburtynsky.com

JOHN GANIS
born Chicago, IL, 1951 I resides Pleasant Ridge, MI

Six chromogenic prints from *Consuming the American Landscape*, 1984–2003, each 13" x 19."

Comprising some eighty photographs shot over two decades, John Ganis's recently published *oeuvre* presents a broad view of the American landscape, cataloguing its various forms of use and misuse, including oil extraction, mining, re-development of farm land, suburban sprawl, deforestation, toxic waste management, and landfills. Ganis asserts his wish to "cause the viewer to reflect on the American legacy of consumption" (*Consuming*, 141). Underlining our general misapprehension of the real cost of resource extraction, Ganis gives a clear image of the stresses brought to bear on the land, while retaining a reverence for the altered landscape. Images like the landfill near Milford, Michigan, expose the proximity of such dangers. Among other evils, Ganis points to deforestation, which, on the one hand, diminishes arable land through erosion and, on the other, reduces the most efficient means of absorbing greenhouse gases. As Peter Goin notes in his introduction to *Humanature*, one further result of deforestation is an unexpected increase of the world termite population to a ratio of nearly one-half ton per capita (p. 1). What makes this significant is the fact that termites produce vast amounts of methane gas, which traps solar radiation, further raising the temperature of the planet.

Ganis, John. *Consuming the American Landscape.* Stockport, UK: Dewi Lewis, 2003.
www.johnganis.com

PETER GOIN
born Madison, WI, 1951 I resides Reno, NV

Two single images, one diptych, and one triptych, all chromogenic prints, 1986–92, ranging from 16" x 20" to 23.5" x 82."

A well-known environmental activist, Peter Goin has published several collaborative and multi-dimensional projects, defining the American landscape from mining to nuclear testing. In *Changing Mines in America,* co-written with landscape historian C. Elizabeth Raymond, eight case studies explore the cultural and mythic significance of mining in America, which, despite its negative environmental connotations, remains a major economic force as well as a nostalgic trope in frontier mythology. According to the National Mining Association, in 2004, the average mineral use per capita in the U.S. was 46,414 pounds (www.nma.org/pdf/m_consumption.pdf). To take but one example, Arizona's Clifton-Morenci Pit, with its gargantuan scale, raises questions about what sort of price we are willing to pay for maintaining current levels of consumption on all fronts. From the pooling of toxic waters to the rehabilitation of vast tracts of land, mining continues to challenge us to square extraction and consequence, arriving at the real cost of such consumption. In *Humanature*, Goin looks beyond the landscape in crisis, revealing the complex relationships between the environment, its flora and fauna, and human intervention—both exploitive and aesthetic. Pointing out that "domestic populations of dogs, cats, cows, and horses continue to replace the splendid variety of native wildlife," the artist underlines the insidious consequences of seemingly innocent practices (p. 1). In *A Doubtful River*, Goin and co-authors Robert Dawson and Mary Webb examine Nevada's Truckee River as a means to address water use in the West, a mounting crisis exacerbated by the growing migration to the desert climates of California and Nevada, whose very existence flies in the face of sustainable land use practices.

Goin, Peter. *Humanature.* Austin: University of Texas Press, 1996.
_____. *Nuclear Landscapes.* Baltimore: John Hopkins University Press, 1991.
Goin, Peter, and C. Elizabeth Raymond. *Changing Mines in America.* Santa Fe, NM, and Staunton, VA: The Center for American Places, 2004.
Goin, Peter, Robert Dawson, and Mary Webb. *A Doubtful River.* Reno: University of Nevada Press, 2000.
www.http://equinox.unr.edu/homepage/pgoin/default.htm

EMMET GOWIN
born Danville, VA, 1941 I resides Newtown, PA

Ten toned gelatin silver prints from *Changing the Earth*, 1986–96, ranging in scale from 9.5" x 9.5" to 14" x 14." Courtesy of the artist and Pace/MacGill Gallery, New York.

Emmet Gowin's photographic subjects read like a litany of deadly sins: *Aeration Pond, Toxic Water Treatment Facility, Arkansas* (1989), *The Razed Village of Libkovice, Bohemia, Czech Republic* (1992), *Hanford Nuclear Reservation, Washington* (1986), *The Abandoned and Condemned Village of Times Beach, Missouri* (1989), *Weapons Disposal Trenches, Tooele Army Depot, Utah* (1991), *Line of Sight Markings and Areas Cleared of Radioactive Soils, Frenchman Flat, Nevada Test Site* (1996). Broadly acclaimed for his work, Gowin gained first recognition for a compendium of portraits of his wife Edith's extended Virginia family begun in 1965. Gowin's work has always contained a sensual intimacy and a measure of materiality that is nearly palpable. A master printmaker in an age when few go near a darkroom, Gowin's works defy Walter Benjamin's supposition that the aura of art is lost in the age of mechanical reproduction. How then, to reconcile such formal beauty with such toxic ugliness? This question could be posed with any number of the artists in *Imaging a Shattering Earth*; whatever the response, one cannot ignore a thing of beauty, and when that thing points at

something else, then that too must be acknowledged. Gowin catalogues an exhausting list of man-made spoils. His intimately scaled works draw us in and leave us with questions like: What happened here? Has anything changed? Who is responsible? It is up to us the find the answers for ourselves. No one is likely to volunteer them.

Gowin, Emmet. *Photographs*. Philadelphia: Philadelphia Museum of Art; Boston: Bulfinch Press, 1990.

Reynolds, Jock. *Emmet Gowin: Changing the Earth, Aerial Photographs*. New Haven, CT: Yale University Art Gallery, in assoc. with The Corcoran Gallery of Art and Yale University Press, 2002.

DAVID T. HANSON
born Billings, MT, 1948 I resides Fairfield, IA

Six triptychs from the *Waste Land series*, 1985–86, each comprised of a modified U.S. Geological Survey map, a chromogenic print, and a gelatin silver print text panel quoted from reports issued by the Environmental Protection Agency, each 17.5" x 47."

David T. Hanson has spent more than twenty years reflecting upon America's industrial and military abuse of the land in the related series, *Colstrip, Montana* (1982–85), *Minuteman Missile Sites* (1984–85), *Waste Land* (1985–86), and *"The Treasure State": Montana 1889–1989* (1991–95), all published in *Waste Land: Meditations on a Ravaged Landscape*. From a bird's-eye view, Hanson has documented a stunning array of toxic spoils and lethal weapons. His *Waste Land* series describes sixty-seven sites from the Environmental Protection Agency National Priorities List (EPA NPL). Promulgated by the Superfund program established in 1983, the list contains, as of September 2005, 1,307 final and proposed sites, which represent those areas deemed most likely to pose a risk to health or the environment. Of the six sites presented here, two have been deleted from the Superfund list: Love Canal and Sharon Steel's Midvale Smelter, both effective as of 2004. Times Beach, listed in 1983, was cleaned up by 1997, and re-opened as a state park in 1999. All of its former residents have been permanently relocated. Colorado's Rocky Mountain Arsenal continues to rank as one of the most hazardous sites on the NPL. In 1992, Congress mandated the Arsenal to become a National Wildlife Refuge, once it is cleaned up, and instated the U.S. Fish and Wildlife Management service to assume its maintenance. An application for deleting portions of the Arsenal from the NPL is pending. The G & H Landfill, located in Michigan between Utica and Rochester, was added to the NPL in 1983. A clean-up decision was issued in 1990. After negotiating an agreement with 14 Detroit companies in 1993, clean-up actions began in 1996. The work was completed in 1999, sixteen years after the site was listed. Michigan's Metamora Landfill was listed in September 1984. Seventeen years later the landfill was capped. Clean-up of the groundwater is now underway.

Hanson, David T. *Waste Land, Meditations on a Ravaged Landscape*. New York: Aperture, 1997.

www.davidthanson.net

JONATHAN LONG
born Rexburg, ID, 1977 I resides Rexburg, ID

Four chromogenic prints from the *Pre-Law Wastelands: Abandoned Mine Lands of Southern Illinois* series, 2002, each 10" x 96."

Emerging photographer Jonathan Long focuses on abandoned coal-mining sites in Southern Illinois exploited during the nineteen forties—the "pre-law" era of environmental regulation. Prior to the passage of the Clean Air and Clean Water Acts (respectively 1970 and 1977), such areas were regularly cleared of trees, mined, and subsequently abandoned. Torn up and littered with long-buried rocks that leach acids into the surrounding soil, these languishing sites are also a source of contamination for surrounding streams and rivers. Decrying the current politics of environmental deregulation, Long intends his work to stand as a reminder of and a warning against the consequences of repealing environmental laws. Emphasizing the scope of devastation, Long's camera lens rotates 360 degrees (resulting in a 2.25" x 20" negative) describing the land in every direction as far as the eye can see. As an alternative to the prints presented here, Long hangs murals (measuring 4' x 46') in a series of round enclosures, giving viewers an immersive view of the site.

www.jonlong.com

www.photoeye.com/gallery

DAVID MAISEL
born New York, NY, 1961 I resides Sausalito, CA

Three chromogenic prints from *The Lake Project*, 2001–02, each 48" x 48." Courtesy of the artist and Von Lintel Gallery, New York.

For the past twenty years, David Maisel has pursued aerial photography in an ongoing examination of human activity on the earth's surface in a project entitled *Black Maps*. Making his first flight as a student of Emmet Gowin, Maisel has focused on the environmental impact of such practices as strip mining, clear cutting, and water redirection. In 2001, Maisel turned his attention to the Owens (dry) Lake region, after noticing its iridescent pink glow while driving through southeastern California. Serving as Los Angeles' primary source of water between 1913 and 1926, Owens is now a dry lake, whose mineral flats contain high concentrations of arsenic, nickel, and cadmium, as well as copper, sodium, chlorine, iron, calcium, potassium, sulphur, aluminum, and magnesium. Vulnerable to high winds, the Owens Lake region releases, on an annual basis, over 300,000 tons of cadmium, chromium, arsenic, and other materials in carcinogenic dust storms, creating health hazards far beyond the valley itself. Notorious as the highest source of particulate air pollution in the U.S., the Owens Lake region is now the object of an Environmental Protection Agency reclamation project, which is introducing both water and resilient salt grasses back into the area. Maisel's two shooting trips have captured the lakebed in two states of what is now an ongoing cleanup process.

Gaston, Diana. "Immaculate Destruction: David Maisel's *Lake Project*." *Aperture* no. 172 (fall 2003): 38–45.

Maisel, David. *The Lake Project*. Tucson, AZ: Nazraeli, 2004.

www.davidmaisel.com

DAVID MCMILLAN
born Dundee, UK, 1945 I Resides Winnipeg, MB

Six chromogenic prints from *The Chernobyl Exclusion Zone* series, 1994–present, each 16" x 20."

Early on the morning of 26 April 1986, following a test necessitating the shutdown of several critical safety systems, the flow of coolant water stopped on the Chernobly-4 reactor. The immediate result was a chain reaction causing the ignition of several tons of graphite insulating blocks. Burning for nine days, this fire caused the release of two hundred times the amount of radioactivity released upon Hiroshima and Nagasaki. Despite the radiation that will persist in Chernobyl for the next 48,000 years, human habitation may again be taken up in the next 300 to 900 years. One-hundred-thirty-five-thousand people were evacuated (many only thirty-six hours after the meltdown) from a thirty-kilometer "dead zone" (Helena Filatova, www.kiddofspeed.com/chernobyl-revisited/). It is this area that David McMillan began photographing in 1994, returning for the tenth time in fall 2005. Though heavily monitored, entry into the Chernobyl exclusion zone is now relatively common, the reactor having been encased in a steel and concrete shell known as the sarcophagus. Not quite "before and after" views, McMillan's rephotographic documentation serves as a silent witness to an "afterlife" that is really

an ongoing series of aftermaths to an unfathomable environmental, economic, and human disaster.

Fitzpatrick, Blake. "Disaster Topographics." In *Image and Inscription: An Anthology of Contemporary Canadian Photography*, edited by Robert Bean. Toronto: YYZ Books and Gallery 44, 2005.

Fitzpatrick, Blake, and Robert Del Tredici. *The Atomic Photographers Guild: Visibility and Invisibility in the Nuclear Era*. Toronto: Gallery TPW; Peterborough, ON: The Art Gallery of Peterborough, 2001.

Sowiak, Christine. *That Still Place . . . That Place Still*. Calgary: The Nickle Arts Museum, 2003.

ROBERT and SHANA PARKEHARRISON
RPH born Fort Leonard Wood, MO, 1968 | SPH born Tulsa, OK, 1964 | reside Boston, MA

Four photogravures from the *Reclamation* series, 2003, one photogravure from the *Procession* series, 2004, each 20" x 24."

In 2001, after many years of an evolving collaboration, the ParkeHarrisons began to exhibit their work recognizing both Robert and Shana as co-creators. Motivated by an urgent preoccupation with raising environmental awareness, their work is situated somewhere between photography, performance, sculpture, and painting. Developing a personal vocabulary drawing from such cultural idioms as cartoons, fairytales, poetry, literature, painting, and theatre, the artists have created an everyman who moves from one impossible attempt at healing the earth to another. Equal parts savior and fool, their everyman is an apt emblem for our fumbling efforts to save the planet by half measures. In their most recent works, apparently set within an endgame of environmental disaster, the ParkeHarrison's alter-ego is seemly engaged in a process of attempted rehabilitation—literally teaching the earth to return to old cycles: to remember to rain, to rotate, to cloud over, to grow anew, as if through sheer determination we could make a difference.

ParkeHarrison, Robert. *The Architect's Brother*. Santa Fe, NM: Twin Palms, 2000.

www.parkeharrison.com

JOHN PFAHL
born New York, NY, 1939 | resides Buffalo, NY

Four chromogenic prints from the *Smoke* series, 1988–90, each 20" x 20."

For over three decades, John Pfahl's work has investigated problems of perception, fusing traditions of landscape representation, color photography, and conceptual art. Beginning with his interventionist *Altered Landscapes* (1974–78), followed by his deceptively beautiful *Power Places* series (1981–84), and more recently with his *Piles* (1994–98) images of recycling and refuse, Pfahl has mounted a subtle attack on our assumptions regarding the environment. In the late eighties, Pfahl began photographing the smoke billowing from the stacks of Bethlehem Steel's coke plant, whose annual emissions release as much as 1.4 billion tons of benzene into the atmosphere (*Smoke* artist statement, www.johnpfahl.com). Ever more relevant in the current climate of deregulation, *Smoke*, akin to the famous cloud *Equivalents* of Alfred Stieglitz, represents a constellation of significances. Those would include negligence, greed, deceit, ignorance, and, ultimately, failing health. A mountain of evidence compiled by the Environmental Protection Agency in 1999 revealed that a majority of industrial polluters have consistently dodged the air-quality standards established by the Clean Air Act (1970), which required them to steadily reduce emissions by introducing cleaner, more efficient technologies with each newly built facility. After seven years it became apparent that industry had simply resorted to patching up old plants rather than building new ones to standard. In 1976, Congress amended the Clean Air Act with the new-source review or NSR, which required companies contemplating upgrades to install pollution-control devices such as scrubbers, known to reduce emissions up to 95 percent (Bruce Barcott, "Up in Smoke: The Bush Administration, the Big Power Companies and the Undoing of 30 Years of Clean-Air Policy," *The New York Times Magazine*, 4 April 2004, cover article). In 2002–03, the Bush administration implemented a series of rule changes that effectively nulls the new-source review regulations.

Pfahl, John. *A Distanced Land: The Photographs of John Pfahl*. Albuquerque: University of New Mexico, in assoc. with Albright-Knox Art Gallery, 1990.

www.johnpfahl.com

MARK RUWEDEL
born Bethlehem, PA, 1954 | resides Long Beach, CA

Five gelatin silver prints from *The Hanford Stretch, Columbia River*, 1992–93, single works each 24" x 28," diptych 24" x 48." Courtesy of the artist and Stephen Bulger Gallery, Toronto.

Since the early nineties Mark Ruwedel has photographed both human and geologically induced traces on the lands of the American West in conceptually related series such as *Westward the Course of Empire*, examining the expansion of the railroads; *Earthworks*, recording the land-based artworks of sculptors like Robert Smithson; *The Ice Age*, tracking the migratory routes of ancient peoples; and *The Italian Navigator*, tracing the legacy of the U.S. Military's weapons programs. *The Hanford Stretch*, Mark Ruwedel's self-published photographic project comprising twenty images, tracks the journeys he and several companions made along a 50-mile segment of the Columbia River in 1992–93. Home to nine nuclear reactors operating between 1944 and 1990, eight of whose radioactive cores were cooled by waters flowing directly to and from the Columbia River, the Hanford Works produced 74 tons of weapons-grade plutonium. Given thirty days to evacuate back in 1943, the residents of Hanford and White Bluffs had no choice but to leave when their isolated towns were chosen by the Manhattan Project as a site of plutonium production that would eventually supply over half the total U.S. nuclear arsenal. The Hanford Reservation is today considered one of the most toxic sites in the U.S. Controversy continues to follow efforts at containment in the wake of the reactor shut-downs. While the Environmental Protection Agency struggles to find a "long term" solution to the 53 million gallons of plutonium-laden sludge stored in 177 underground containment tanks, "leaks in a third of those tanks have leached a million gallons of toxic goo into the earth" (Christopher Helman, "Waste Mismanagement," *Forbes*, 18 August 2005, www.forbes.com/2005/08150/035.html). In the meantime, construction on the high-tech containment facility has been halted because "the structural steel design of the Analytical Laboratory at Hanford's massive vitrification plant does not meet commercial building standards used nationwide" (Annette Cary, "Hanford Lab Building Lags Behind," *Tri-City Herald*, 14 September 2005, www.tri-cityherald.com/tch/local/v-rss/story/6966909p-6867036c.html).

Love, Karen, ed. Mark Ruwedel: *Written on the Land*. North Vancouver: Presentation House Gallery, 2002.

Ruwedel, Mark. *The Hanford Stretch, Columbia River*. Montreal: Self-published, 1993.

_____. *The Italian Navigator*. Montreal: ART 45; Toronto: Stephen Bulger Gallery; Paris: Galerie Françoise Paviot, 2000.

Catalogue entries by Katy McCormick

Acknowledgments

Throughout the academic year 2005–06, the College of Arts and Sciences at Oakland University celebrates *Environmental Explorations*, a liberal arts theme meant to foster awareness of the biological, social, and cultural conditions that influence our world and shape our environment.

Endorsed by the *Environmental Explorations* Planning Committee led by Chemistry Chair Mark W. Severson, this exhibition and catalogue could not have been undertaken without the generous financial contribution of the College of Arts and Sciences. For this, we are grateful to David J. Downing, now Interim Vice Provost for Graduate Education and Academic Administration, who, in his former capacity as Dean of the College, responded with enthusiasm to the initial proposal. Without his foresight and encouragement, that of his interim successor Ronald A. Sudol, and of Associate Deans C. Michelle Piskulich and Kathleen H. Moore, this project would not have materialized.

The Meadow Brook Art Gallery, its director Dick Goody, and the exhibition curator also wish to acknowledge the Office of the Vice President for Academic Affairs and Provost, the Department of Art and Art History, The Honors College, and e-Learning and Instructional Support for their valuable assistance with the related programs of public lectures, discussion panels, student symposium, and exhibition Web site. Without the concerted efforts of Provost Virinder K. Moudgil, Art and Art History Chair Susan E. Wood, Honors College Director Jude V. Nixon, and Assistant Vice President for e-Learning and Instructional Support Catheryn Cheal, the scope of this educational program would have remained more limited.

While in the planning stages, the project evolved into a full-fledged partnership with CONTACT Toronto Photography Festival, which made feasible a more substantial publication and the presentation of the exhibition in Toronto as part of CONTACT 2006. For making this collaborative venture possible, Oakland University is grateful to CONTACT's Executive Board members Edward Burtynsky, Stephen Bulger, and Paul Bain and Festival Director Bonnie Rubenstein. We also wish to express our appreciation to Museum of Contemporary Canadian Art Director David Liss for his interest in the project. We look forward to viewing *Imaging a Shattering Earth* at MOCCA in May 2006.

We are especially grateful to Robert F. Kennedy Jr., Maia-Mari Sutnik, and Katy McCormick for their engaging contributions to the catalogue, which provide a diversity of perspectives from which to reflect upon photography and the environmental debate.

For their kind assistance in securing the permissions to reprint the essay by Robert F. Kennedy Jr., we thank Jean Ann Miller, Director, The Center for Student Activities and Leadership Development, Paul L. Franklin, Coordinator of Campus Programs, and Caroline Berton, Condé Nast Publications, Paris.

For their dedication to the exhibition Web site, available at www2.oakland.edu/shatteringearth, we thank Oakland University Web Application Developer Shaun Moore and the twenty dedicated students enrolled in Baillargeon's fall 2005 Honors College seminar "Imaging a Shattering World: Art, Public Health, and the Environmental Debate": Keiko Andress, Jonathan Benefiel, Neena Bhullar, Jamie Bide, Mollie Braun, Hebert Cabral, Sean Collins, Erika Eraqi, Dan Jakubowski, Kaya Khani, Anthony Leo, Meghann Lloyd, Heather Mulrenan, Christine Nguyen, Kristen Osmond, Julie Peplinski, Megan Stewart, Jordan Twardy, Kelly Walewski, and Jean Wood.

The following individuals also deserve recognition for their timely assistance: Debra Lashbrook, Art Director, Oakland University Communications and Marketing; Jacqueline Leow, Assistant to the Director and Registrar, Meadow Brook Art Gallery; Leigh Fifelski, Regional Conservation Director of the Oakland County Sierra Club; Marcus Schubert, Production Manager, and Karen Machtinger, Arts Administrator, Office of Edward Burtynsky; Jeannie Baxter, Toronto Image Works; Kristen Adloch, Manager, Stephen Bulger Gallery; and Doug Stone for his careful handling of the art in transit.

Lastly, our most sincere gratitude to the twelve contributing artists for their inspiring, though tragic images, each of them a warning—like the perennial canary in the gold mine—of what awaits us if we do not heed the signs of impending danger.

Exhibition and catalogue co-produced by

 Meadow Brook Art Gallery
Department of Art and Art History
College of Arts and Sciences
Oakland University
208 Wilson Hall, Rochester, MI 48309-4401
(248) 370-3005 I www.oakland.edu/mbag

Director, Dick Goody
Assistant to the Director and Registrar, Jacqueline Leow

CONTACT

CONTACT Toronto Photography Festival
258 Wallace Avenue, Suite 204
Toronto, ON M6P 3M9
(416) 539-9595 I www.contactphoto.com

Executive Board of Directors, Paul Bain,
Stephen Bulger, and Edward Burtynsky
Festival Director, Bonnie Rubenstein

 michigan council for arts and cultural affairs

The MBAG presentation is also made possible in part by a grant from the Michigan Council for Arts and Cultural Affairs

Catalogue edited by and sequenced by Claude Baillargeon, designed by Debra Lashbrook, Oakland University Communications & Marketing, and printed by Tepel Brothers Printing Company.

For exhibition related programs, please visit www2.oakland.edu/shatteringearth.